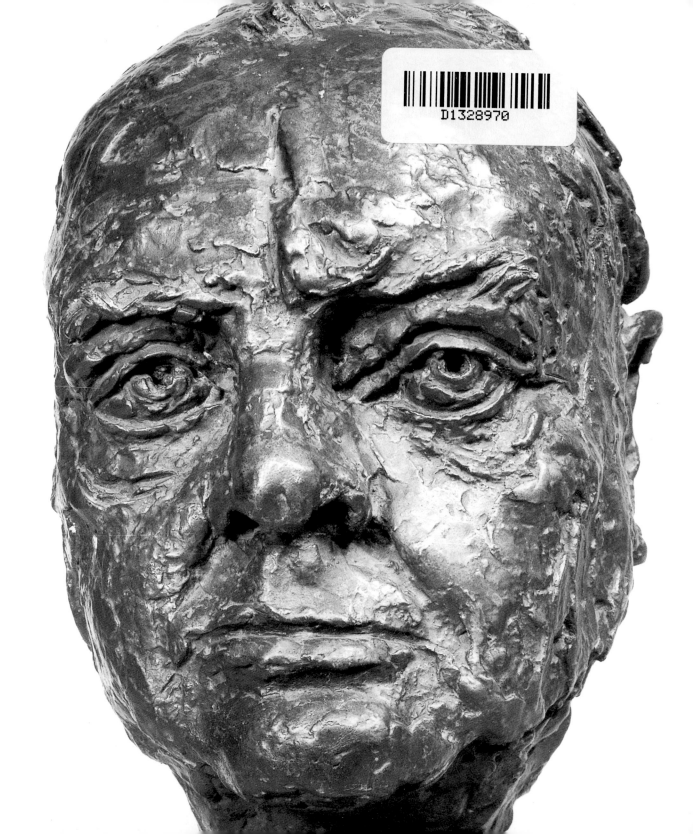

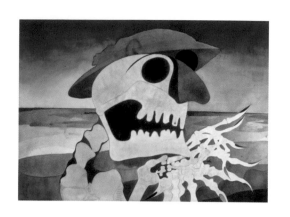 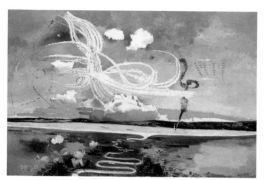 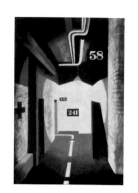

Art from the

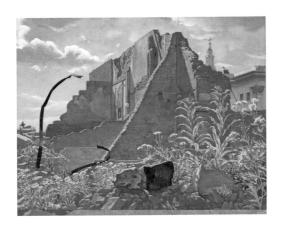
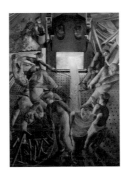
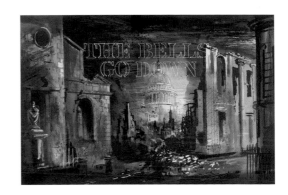

Second World War

Imperial War Museum

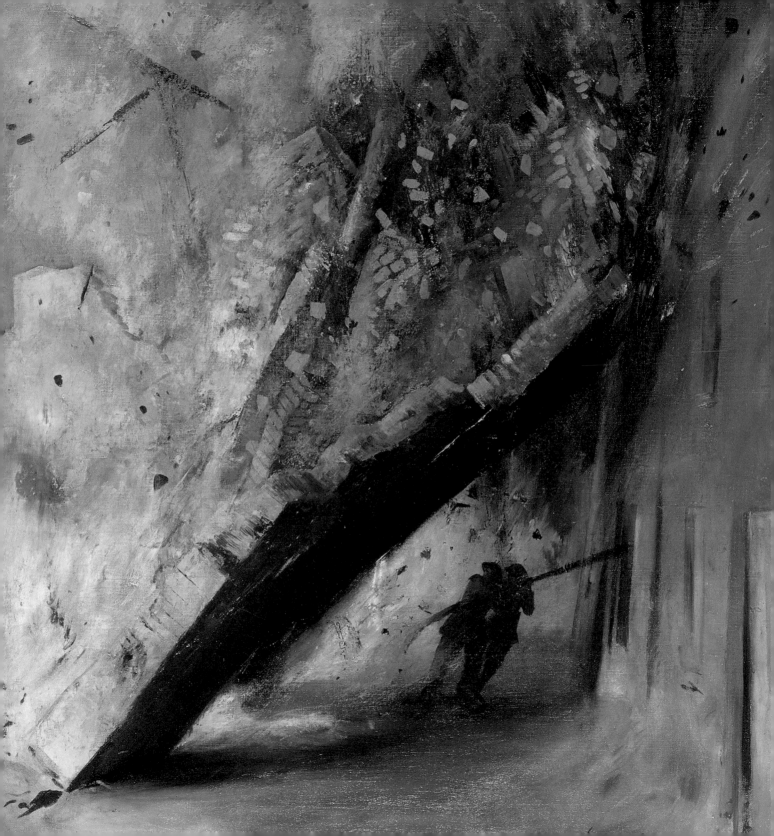

Introduction

The images selected here from a collection of 7,000 works, represent events and lives in extremity. Whether facing death or working for life, stories both personal and national are revealed that capture responses to the war, as well as shaping our memory of it. The collection, built on the substantial work of the War Artists Advisory Committee (WAAC) during the Second World War, continues to grow, adding to a rich, diverse and compelling picture of social and military life during the war, as well as artistic practice.

The development of official artist schemes during the First World War enabled an art that was not idolising or unquestioningly supportive of government and leaders. The honesty and integrity of eye-witness artists allied to deliberately liberal patronage resulted in a set of images that grappled with the painfully complex consequences and morality of war. The impact on a young Kenneth Clark, taken to see the exhibition of Canadian war art at the Royal Academy in 1917, which included work by many leading British artists, was significant and long lasting. Clark, later to become Director of the National Gallery, was the driving force to establish a British War Artists Scheme within the Ministry of Information that was ready to appoint artists at the outbreak of hostilities in 1939 and that would ultimately commission some of the finest British art of the twentieth century. As an act of state patronage the project was not unprecedented: in addition to the First World War schemes, the Federal Art Plan in the United States was still operating at the beginning of the war, but by any standards the scale and scope of the scheme was extraordinary, employing over 400 artists and acquiring some 6,000 works, over half of which were transferred to the Imperial War Museum. Clarke strongly emphasised the unique role of art, and in particular the insight and vision that artists could bring to our understanding of the war. The message was aimed primarily at an educated art audience in Britain who,

following the First World War, were inured to any overt propaganda. Such was Clark's sensitivity to these issues, that anything obviously didactic or morale raising was carefully avoided. As in the First World War, there was an emphasis on the production and purchase of high quality art that would embody a message about liberal cultural values: the antithesis of the controlled and centralised aesthetic of the Nazis. An extensive wartime exhibition programme, both within the United Kingdom and overseas, attracted new and diverse audiences to see images of war when other forms of popular entertainments largely steered clear of the subject.

The project employed most of the leading British artists of the day, providing what Anthony Gross described as 'a governmental magic carpet'[2] that both took artists on great journeys across the globe as well as giving direction and focus to their practice. For many this was the pinnacle of their careers: the spectacle of the new; a strong sense of duty; the immediacy of the unfolding events; the matching of artist to subject; and the assurance of employment following years of reduced opportunities all combined to demand and enable exceptional work. From Stanley Spencer's fantastical teeming shipyards to the empty desolation of Graham Sutherland's city and landscapes, and from Paul Nash's carefully constructed imagery of the power and resolve of British resistance to Edward Ardizzone's intimate scenes of daily life, the collection demonstrates the artistic variety and ambition of the official scheme. (Incidentally, it also provides a fascinating snapshot of a particular period of British art, with an emphasis on artists associated with the neo-Romantic Movement.)

There were, however, some notable omissions from the official programme, artists whose work was deemed too abstract or symbolic but who were nonetheless affected and moved by the war. Not working under official auspices, their work is often more expressive of the artists' personal concerns and experiences than a straightforward record of wartime activity. Their vision is often disturbing and challenging as they expose a more unsettling world of disorder and dysfunction, where fears and threats were more openly expressed. From Colquhoun's uncomfortable shelterers and the brutal aggression of Burra's skull, to Tunnard's long-gazed seascapes and Armstrong's denouncing of the rise of Fascism, they use a more personal visual language that might not be so immediately accessible but is rich in suggestion and symbolism. That they were able to continue without official support is both testament to their will and the extent to which the war affected all of society.

Combined, these two strands have created a rich and complex picture of the war, from which certain themes and subject matter emerge, both guided by official commissions and contemporary thinking. Rural life, so closely associated with English identity, is reaffirmed and its traditional skills shown to continue, or to be re-learnt; churches and cathedrals, the great

symbols of national heritage now left standing amidst the destruction of the Blitz, are the source of hope and salvation; offices and factories are the stages for a shifting social order, adjusted and attuned to wartime needs, the employment of women and the creeping influence of technology; the arts of electronic observation and visual disguise, so closely linked to the new weapons of warfare, are openly revealed; the exposure of all citizens to threat is plainly demonstrated alongside their role in creating threats of our own; the need to heal, repair, make do and carry on is painfully honest; social visions are explored in stark contrast to the desperate immorality of the newly exposed atrocities at Belsen and in the Far East. Finally, alongside the great dramas of the Battle of Britain and D-Day, the images of service life emphasise its unfamiliarity and awkwardness, its boring and repetitious duties, as well as the methods of dealing with unremitting threats and constant fragility. So many of the paintings are of night scenes and the desperate need for sleep: a reality for many but also symbolic of uncertain times and the nightmares of waking life.

Out of the strange encounter between the fine arts, with their civilizing values and traditions, and a diverse and technologically driven conflict, emerge personal stories that range from the strains of daily life to world changing events. Through these paintings we see the reality of modern war: not just the displays of force but also the fear and the tedium, and how the familiar could be juxtaposed with the utterly strange and new. We see individuals at their most vulnerable and courageous, and how lives were shaped by extreme needs and everyday routines. The final pair of paintings by Elliott Hodgkin and Leila Faithful, both dated 8 May 1945, capture the contradictions of art, beauty, war and the price of peace. In one, a barely recognisable city is overgrown by weeds and wild flowers, and in the other crowds gather for the first time openly on the streets to celebrate a victory finally achieved.

The collection reveals a history that continues to be distinctive, disturbing and rewarding.

Roger Tolson
Head of the Department of Art
Imperial War Museum

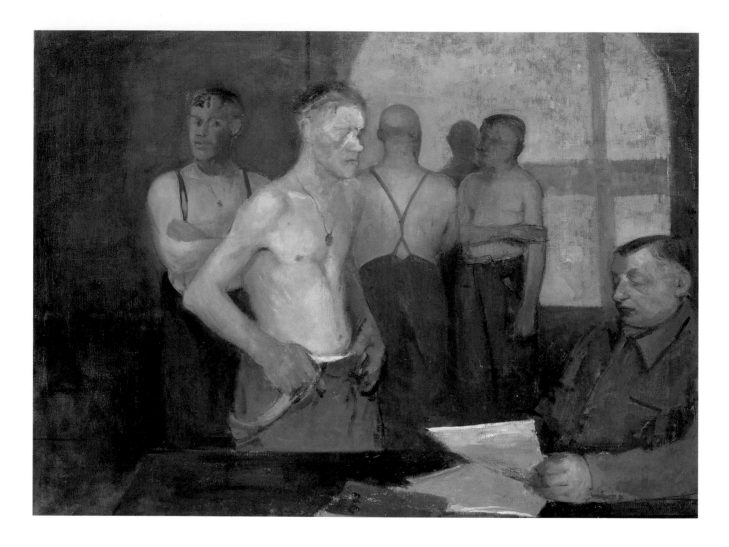

Rodrigo Moynihan CBE, RA

Medical Inspection, 1943

oil on canvas, 91.4 x 121.9 cm

Moynihan found the routines of military life in the Royal Artillery both dispiriting and frustrating. He was given a handful of painting commissions early in the war but after being invalided out, was appointed as an official war artist. The discomforts of his service experience are reflected in this painting, where officialdom, represented by the bored medical officer, is oblivious to the embarrassment of the new recruits.

Evelyn Dunbar

An Army Tailor and an ATS Tailoress, 1943

oil on canvas, 60.9 x 45.7 cm

Dunbar wrote to the WAAC explaining her interest in women's work on the land, and was given a series of commissions related to the Women's Voluntary Service before being offered a contract of employment. She was also commissioned to paint several nursing, and ATS subjects. There is a recurring theme in her paintings of women adapting to unfamiliar work and surroundings as both the war and technology refashioned lives. Here she captures the collective mood of concentration and the individual characteristics of each of the workers as they sew new uniforms.

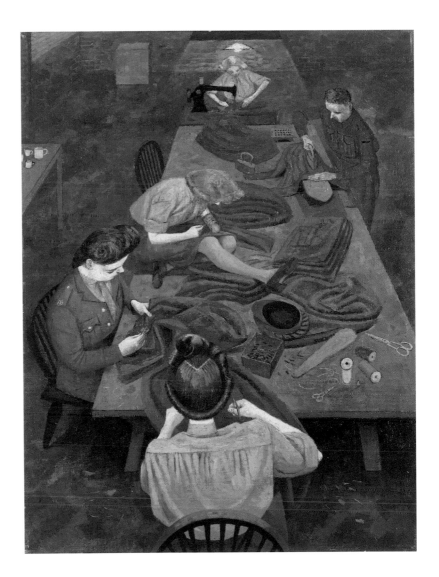

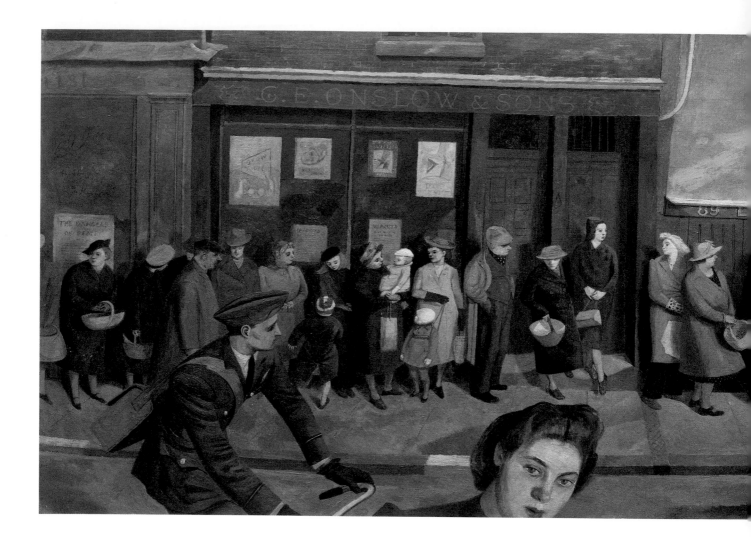

Evelyn Dunbar

The Queue at the Fish Shop, 1944

oil on canvas, 62.2 x 182.8 cm

The shopping queue was not only a symbol of shortages but also part of the difficult process of adapting to the new and daily realities. Although fresh fish was in short supply during the war, and therefore very expensive, being perishable it was never rationed. Fish queues were therefore always long and even air raids could not disperse them.

Dunbar's canvas size emphasises the length of the queue (a cat has joined in, rather hopefully) and her observation of detail shows the determination and expectations of the women and elderly as they carry their large empty baskets and

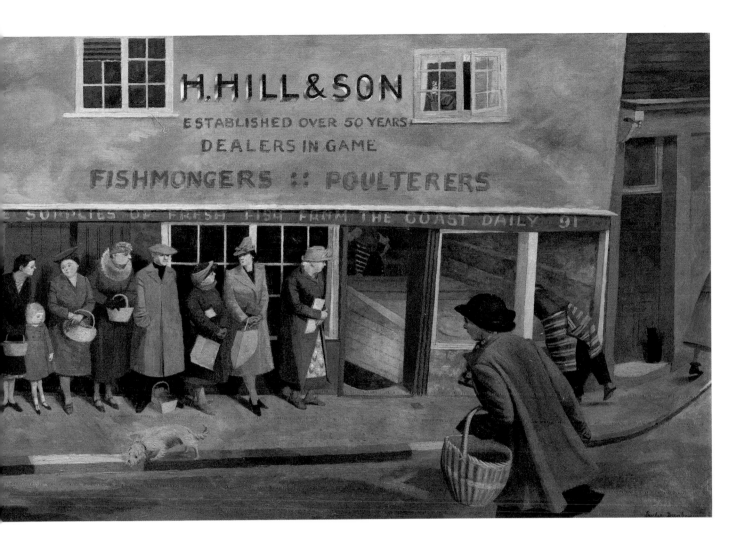

the fishmonger prepares the stall. There is a strong personal narrative in the painting. The view is from the artist's house in Strood, Kent and the woman crossing the street is her sister. The artist herself approaches us from the front of the scene, her attention caught by the RAF man on his bike, her husband, whom she met and married during the war but rarely was able to see.

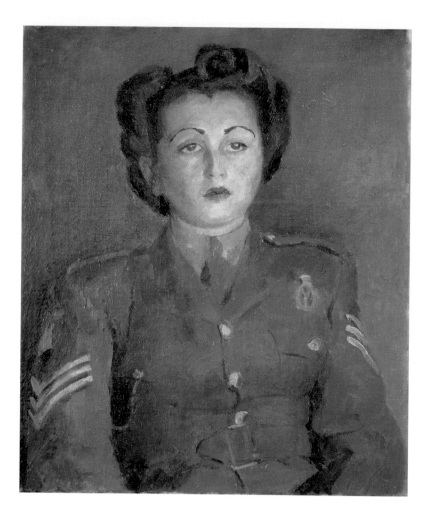

Mary Potter

Portrait of an ATS Sergeant, 1942

oil on canvas, 61.5 x 51.0 cm

Potter captures a life shaped by duty and conscious of its cost. The sitter is Sgt Anita Virginia Flateau who was 'adopted' by her aunt and uncle (Sir Leslie Plummer – the Managing Editor of Express Newspapers) as her parents were living in the West Indies. The Plummers owned Berwick Hall and rented it to the Potter family during the war. The families became good friends and Mary Potter painted a portrait of each of them.

Anita Flateau served in the ATS in a variety of roles: as a shorthand typist, a cipher operator and, finally, as Unit Messing Officer and Education Officer during the last year of her service.

William Coldstream CBE

Havildar Kulbir Thapa: 2/3 Gurkha Regiment, 1943

oil on canvas, 91.4 x 71.7 cm

Coldstream served as an official artist to the Middle Eastern forces before moving into Italy. The sitter, Kulbir Thapa, had won the Victoria Cross in 1915 'for most conspicuous bravery during operations against the German trenches South of Manquisart'. In this quiet, dream-like portrait, he is far removed from the desperation of war.

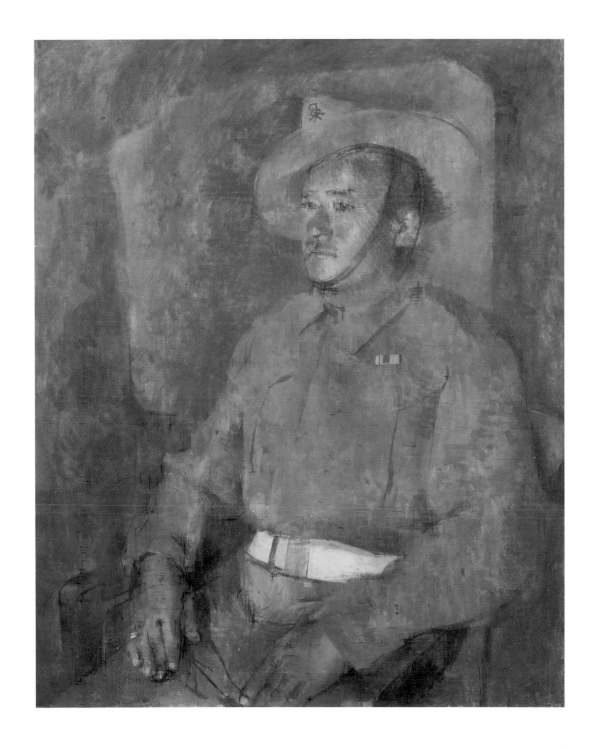

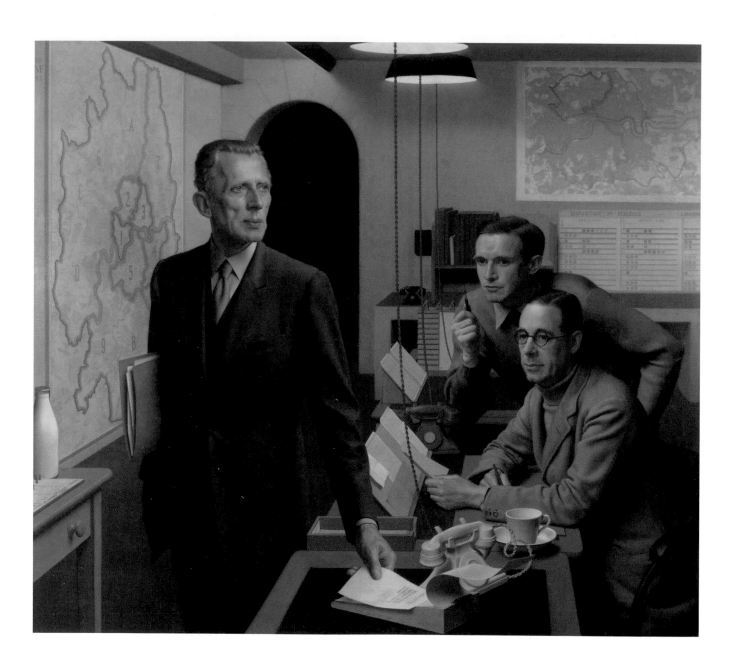

Meredith Frampton RA

Sir Ernest Gowers, KCB, KBE, Senior Regional Commissioner for London, Lt Col A J Child, OBE, MC, Director of Operations and Intelligence, and K A L Parker, Deputy Chief Administrative Officer, in the London Regional Civil Defence Control Room, 1943

oil on canvas, 148.0 x 168.5 cm

The Control Room was based in a specially constructed, highly protected building, sited half underground in Kensington. Its function was to coordinate civil defence operations across the London local authorities, and to collect and evaluate information about the raids and their effects. Gowers was described by *The Times* as 'one of the greatest public servants of his day'.[3] Like Frampton, Gowers was a master of detail.

John Piper CH

The Passage to the Control-Room at South West Regional Headquarters, Bristol, 1940

oil on panel, 76.2 x 50.8 cm

Piper was commissioned in April 1940 to undertake 'a series of pictures of Air Raid Precaution control rooms'.[4] He was taken in great secrecy to see the ARP headquarters in Bristol. The strange lighting, graphics and colours created a modernist, almost brutal space which bore some affinity to the theatrical sets Piper had been designing before the war.

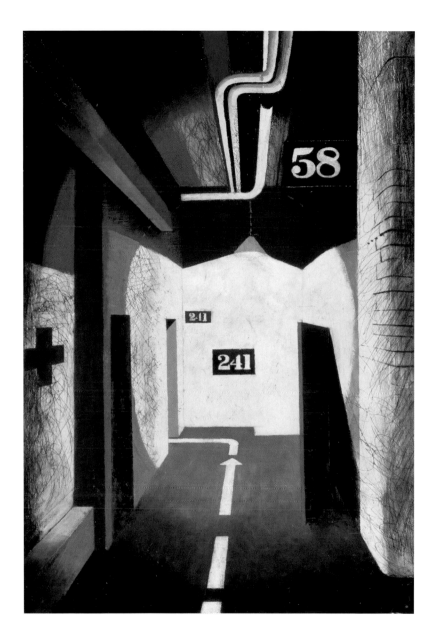

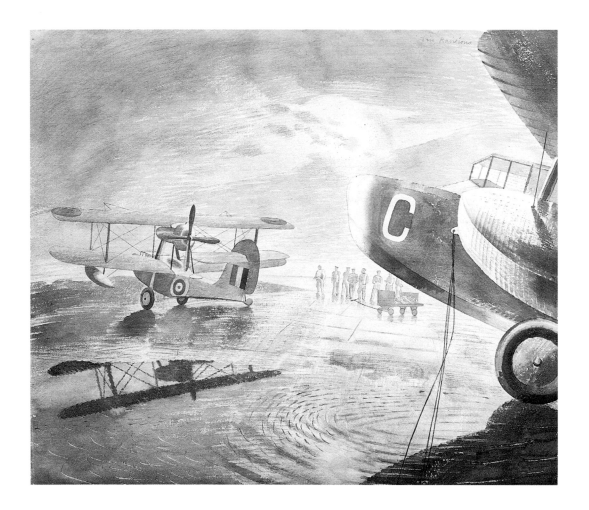

Eric Ravilious

Morning on the Tarmac, 1941

watercolour on paper, 49.5 x 54.6 cm

RNAS Sick Bay, Dundee, 1941

watercolour on paper, 48.8 x 54.2 cm

Ravilious was employed as an official war artist in 1940, first with the Admiralty and then with the RAF. His travels took him to Norway, Scotland, Sawbridgeworth near York, and finally Iceland in August 1942, where he was reported lost in action during an air-sea rescue mission.

These two paintings capture the brilliance of his pattern, order and light. In one, the reflections of sunlight engulf the machines of war in an atmosphere of sublime beauty. The other plays with contrasts: the ordered interior and the expansive, light-flooded seascape; the patterned bed cover and the toy-like planes. He had a particular fascination with Walrus planes: 'I do very much enjoy drawing these queer flying machines… . They are comic things with a strong personality.'[5]

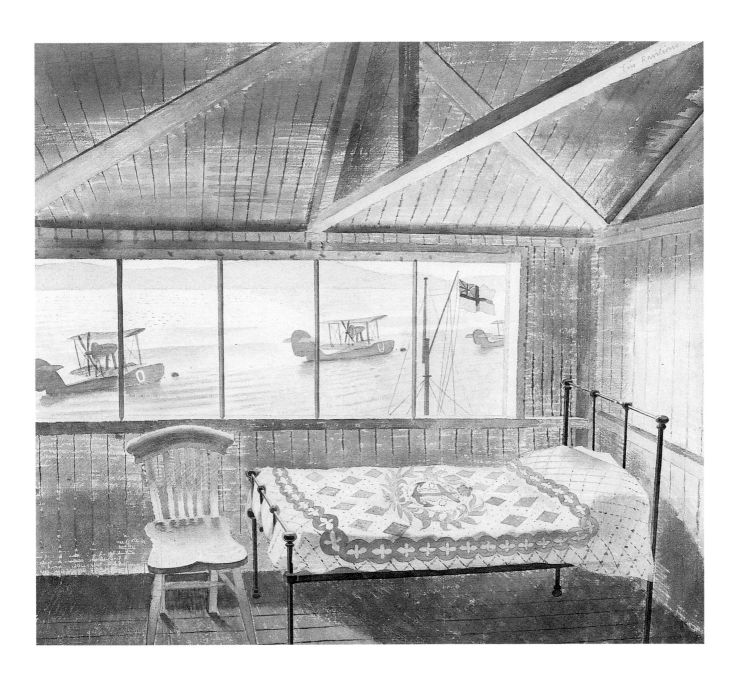

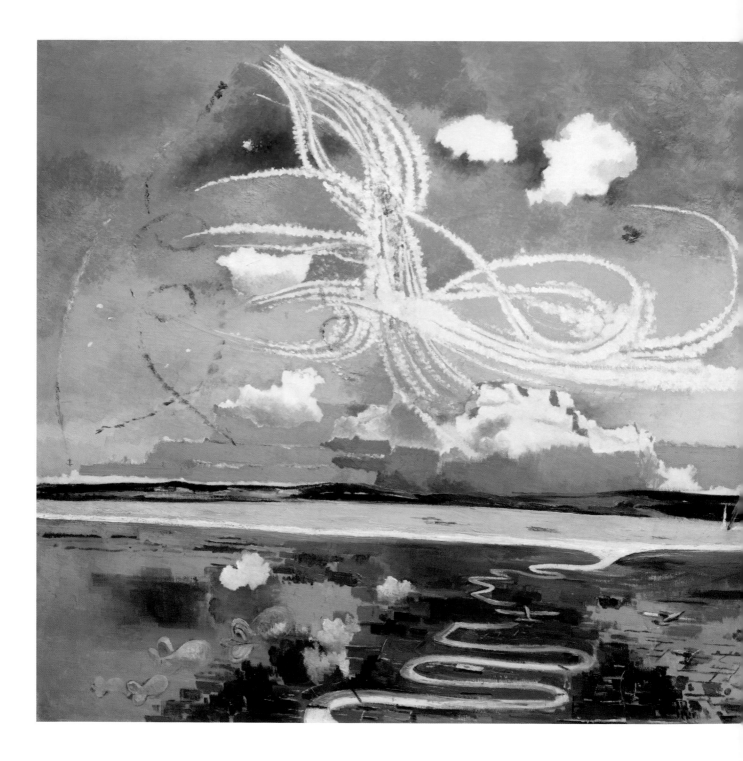

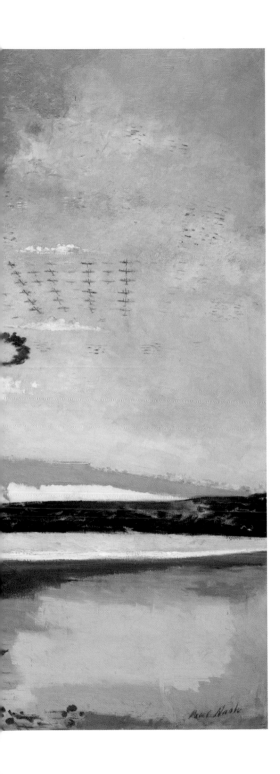

Paul Nash

Battle of Britain, 1941

oil on canvas, 122.6 x 183.5 cm

Nash's *Battle of Britain* majestically reveals the possibilities of art engaged with history. Its ambition and the scale of the setting immediately impress; we look down on a huge swathe of the English Channel and France beyond. Produced at the time of the battle, the painting encapsulates its scale and importance. However, this is not just an image of modern warfare, with its violence and destruction, or even an iconic victory; it is also a restatement of the value of art and the defeat of Nazism. Nash, a fierce critic of the way that fighting on the Western Front of the First World War had been conducted, was immediate and steadfast in his revulsion towards Nazi Germany and its culture. In the painting, defences rise up as if out of the very soil of England to meet the fascistic machines of war; the regimented patterns of the Luftwaffe are broken and defeated by Allied fighter planes, forming great flower-like shapes in the sky, before plummeting into the landscape that has defeated them.

Paul Nash's description of the painting, was written for the WAAC:
'The painting is an attempt to give the sense of an aerial battle in operation over a wide area and thus summarises England's great aerial victory over Germany. The scene includes certain elements constant during the Battle of Britain – the river winding from the town and across parched country, down to the sea; beyond, the shores of the Continent, above, the mounting cumulus concentrating at sunset after a hot brilliant day; across the spaces of sky, trails of airplanes, smoke tracks of dead or damaged machines falling, floating clouds, parachutes, balloons. Against the approaching twilight new formations of Luftwaffe, threatening ...'.[6]

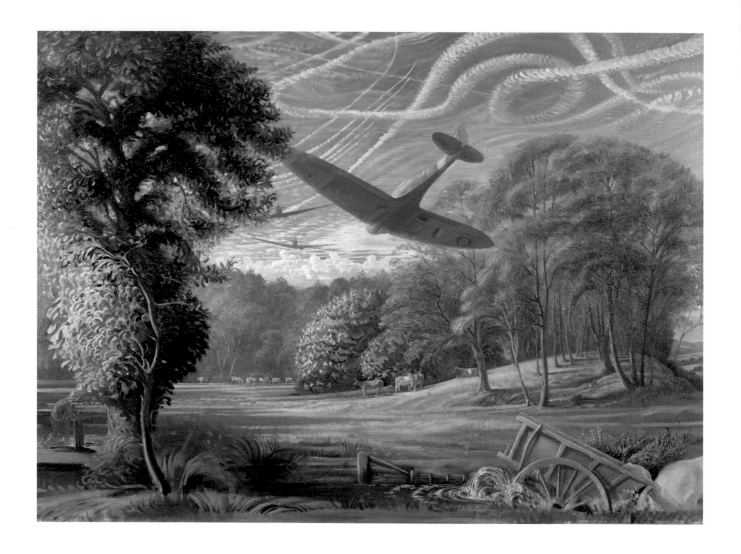

Thomas Monnington PRA

Southern England, 1944.
Spitfires Attacking Flying-Bombs

1944 oil on canvas, 105.4 x 143.3 cm

Modern war machines fly through a scene taken from a Constable painting, relegating the countryside to a backdrop to their deathly conflict. There is a particular tension between the declining economic status of rural England and its continued potency – a symbol of national values to be defended. Monnington had worked at the Directorate of Camouflage at Leamington Spa before being employed as an official war artist.

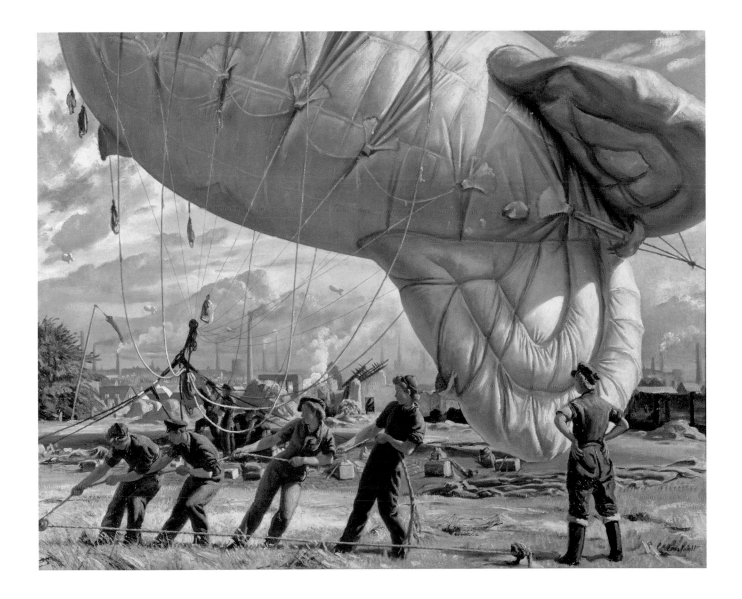

Laura Knight RA

A Balloon Site, Coventry, 1943

oil on canvas, 102.5 x 127.0 cm

Barrage balloons were an integral part of Britain's defences during the Second World War. By forcing German planes to fly at high altitude they reduced the accuracy of their bombing and also made them more vulnerable to anti-aircraft fire. The ballet and the circus were frequent subjects of Knight's paintings and it is the coordinated skills of the balloon team that she emphasises here.

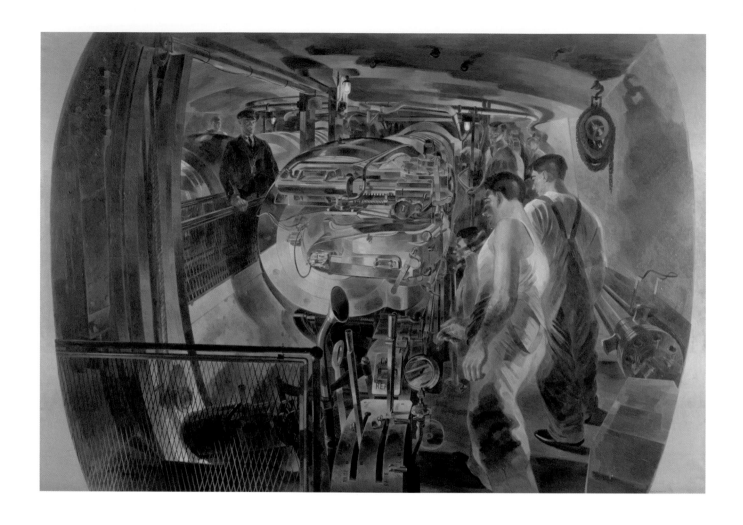

Barnett Freedman CBE

15 Inch Gun Turret, HMS Repulse, 1942

oil on canvas, 200.6 x 292.1 cm

HMS *Repulse* was occupied with convoy protection when Freedman took a commission to work on board. His painting explores the increasingly complex relationship between technology and operator in contemporary warfare.
The enormous 15 inch gun fired shells weighed almost a ton. The crew are wearing training gear, not 'flash' gear, so this is a practice drill, part of an endless need to improve efficiency and master the immaculate choreography required to operate the gun. The machinery weaves a web around the sailors – shaping their working lives in this claustrophobic environment.

Stanley Spencer RA

**Shipbuilding on the Clyde:
The Furnaces, 1946**

oil on canvas, 156.2 x 113.6 cm

Spencer received a commission from WAAC to
record the war effort by focusing on the shipbuilding
industry at Lithgow's shipyards on the Clyde in Port
Glasgow. Furnaces is the centrepiece of the series
and was completed between January and March 1946
from a study made in May 1940. Spencer was
fascinated by the skills and trades of the industry,
rather than the boats themselves (although the series
itself is ship-like in shape and length). His workforce
draws out the hot metal with instinctive teamwork,
before shaping it on the workshop floor.

OVERLEAF:
**Shipbuilding on the Clyde:
Burners, 1946**

oil on canvas, three panels: 50.8 x 203.2 cm, 106.7 x 152.4 cm,
50.8 x 203.2 cm (detail from the central panel)

The burner's job was to cut the steel plates with
oxy-acetylene torches, following the complex chalk
lines the machines could not manage.

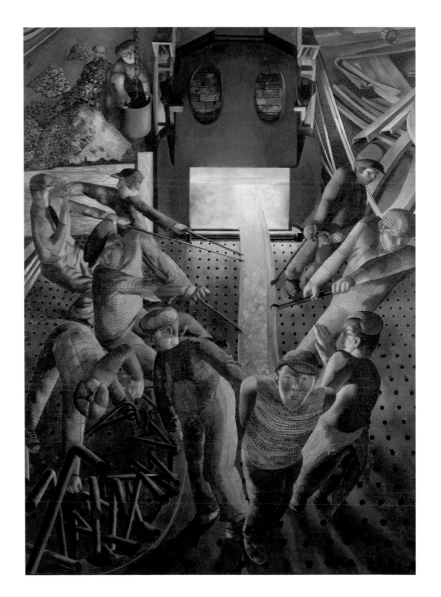

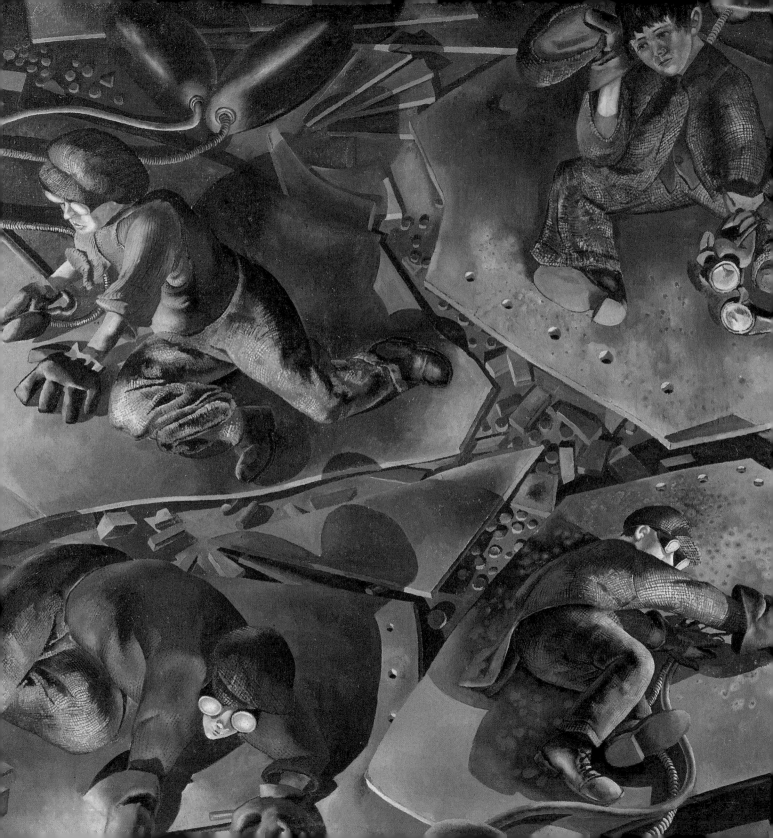

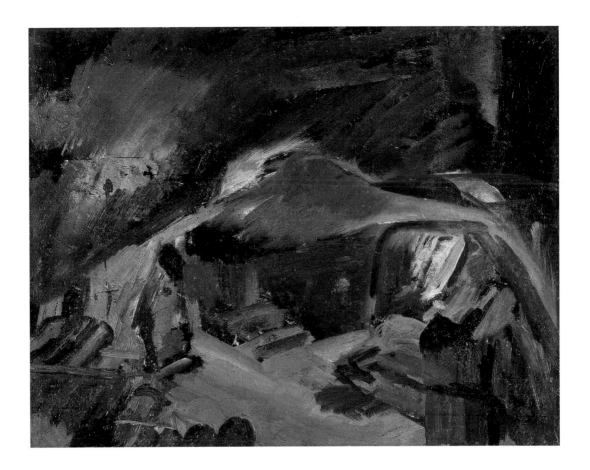

David Bomberg

Bomb Store, 1942

oil on canvas, 59.6 x 75.0 cm
Purchased with the assistance of The Art Fund and the
National Heritage Memorial Fund, 1989

Bomberg's relations with the WAAC were acrimonious. His application to become an official war artist was twice refused, and it was February 1942 before he was commissioned to paint the Burton-on-Trent bomb store. The eerie and destructive scene so fascinated Bomberg that he produced painting after painting, working on greaseproof paper after he finished his meagre canvas ration. Bomberg was deeply frustrated when the WAAC refused the painting he submitted. They accepted three drawings instead but never showed them in the regular exhibitions of war art held at the National Gallery.

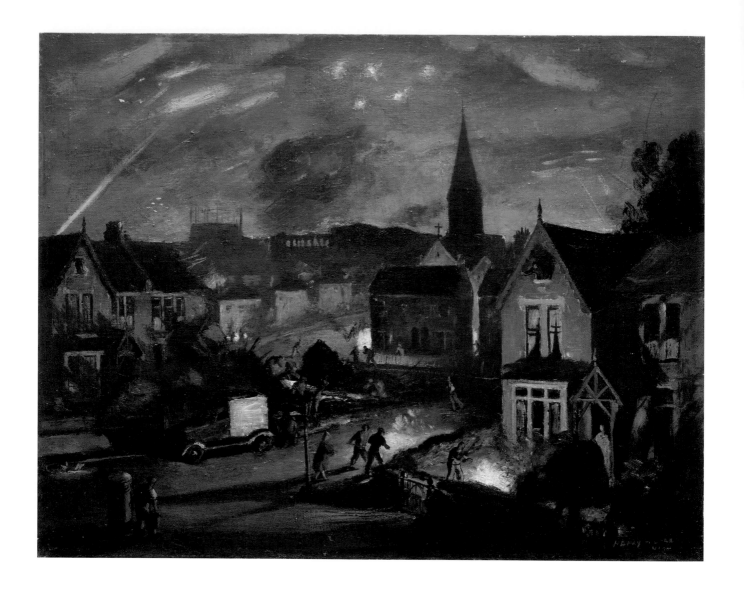

Henry Carr RA

Incendiaries in a Suburb, 1941

oil on canvas, 72.8 x 91.8 cm

This is a jarring image of the suburbs, with street lighting replaced by fires and normal life threatened and disturbed. The sense of urgency is heightened by Carr's rapid brush strokes and scratching of the paint surface. Carr's own house and studio in London were destroyed in the Blitz and he was forced to move to accommodation in Watford.

Mervyn Peake

Glass-blowers 'Gathering' from the Furnace, 1943

watercolour, 50.8 x 68.5 cm

Glass blowers are gathering molten glass as part of the production of cathode ray oscillation tubes. Chance Brothers in Birmingham was the only glass factory in Britain which had developed the technique of blowing this complex shape. The tube was a nineteenth century invention central to the development of television and radar, and by 1943 7,000 tubes were being produced each week. Peake was fascinated by the manufacturing process and by the balletic skills of the workforce.

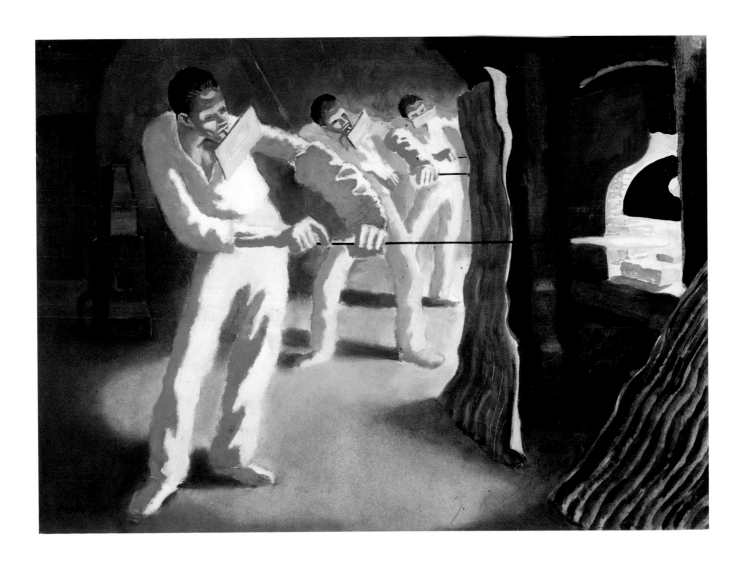

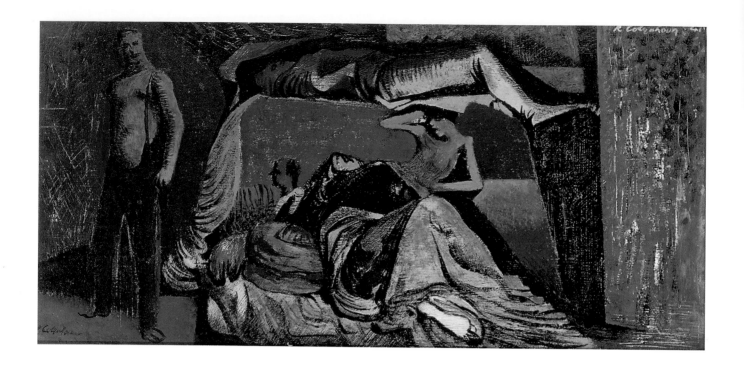

Robert Colquhoun

Figures in an Air Raid Shelter, 1941

oil on panel, 25.4 x 50.2 cm
Supported by The Heritage Lottery Fund
Purchased with the assistance of The Art Fund

After being invalided out of the army, Colquhoun moved to London and worked as a Civil Defence ambulance driver in the day and painted at night. The aggressive stance of the figure on the left (is he protecting the space, or keeping order?); the entombment of the topmost figure; the cramped discomfort of the waking figure; the discontinuity of space; the tight and brutal enclosure, all create a setting that is both theatrical in its design and emotional complexity, and denies any refuge or comfort to the shelterers.

Ruskin Spear CBE, RA

Scene in an Underground Train, 1943: Workers Returning from Night Shift

oil on panel, 58.4 x 71.1 cm

Workers attempted to continue an ordered life amidst the chaos of the Blitz. The windows have been covered in brown tape to block out the light, creating a cocoon-like space where the passengers can sleep, all but briefly. Spear was given a number of commissions during the war. Childhood polio prevented him from active service.

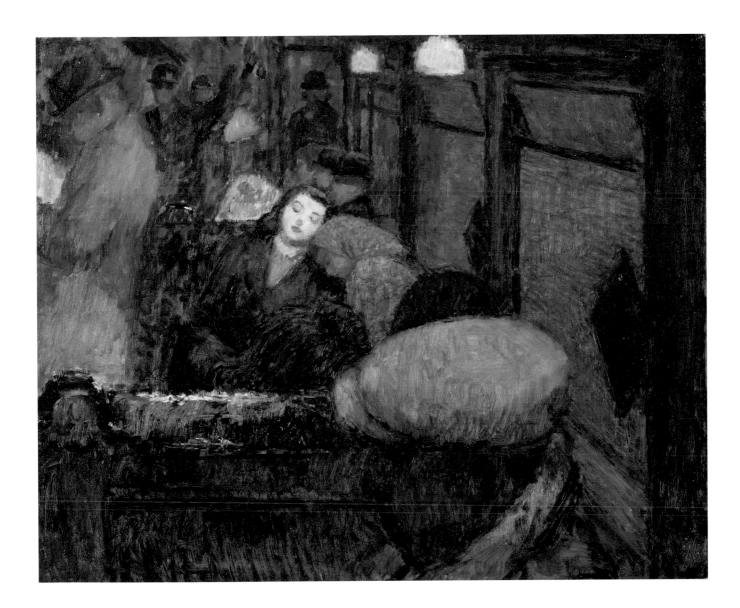

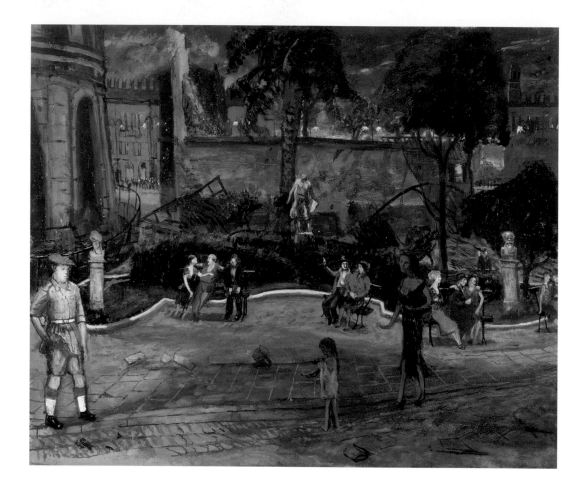

Carel Weight CBE, RA

Veronese Night, 1945

oil on canvas, 50.8 x 60.9 cm

Weight worked as an official artist in Italy and
Greece, documenting the immediate aftermath of
the war: the return of social order amidst the
damaged historic sites, and the changing role of the
army in peace-keeping and re-education. There is a
charming contrast between the uniformed soldier on
duty and those enjoying the warm summer evening.

John Piper CH

The Bells Go Down, 1942,

gouache, ink on paper, 44.1 x 64.4 cm (detail)

This is a draft version of a film poster for *The Bells Go
Down*, and was Piper's first commission from Ealing
Studios. The film, made in 1943, directed by Basil
Dearden, starring Tommy Trinder, James Mason,
Finlay Currie, and Mervyn Johns, was a tragi-comedy
following the lives of a group of AFS volunteers
working in the East End of London during the Blitz.

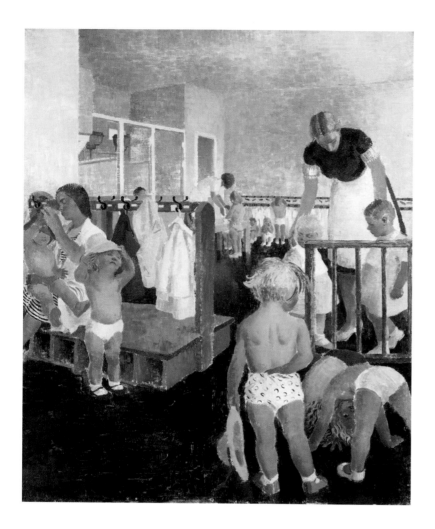

Elsie Hewland

A Nursery-School for War Workers' Children, 1942

oil on canvas, 56.8 x 46.8 cm

The painting hints at the changes not just for the children but also for their mothers called into unfamiliar duties. The children explore their environment, meet their new nurses, prepare for the day and learn new skills at the craft table. Nursery schools were a new support for women conscripted into full-time employment, with over 1,300 schools established by 1943. Although essential the government was keen to stress that they were temporary, providing a solution for wartime needs.

Alfred Thomson RA

A Saline Bath, RAF Hospital, 1943

oil on canvas, 111.7 x 86.3 cm

The tattooed arms of the airman, holding on to the sides of the bath, contrast with the raw scars on his disfigured legs. The nurse, masked and blackgloved, is attentive but remote. This is a painful healing; he is isolated and in uncomfortable, hard surroundings.

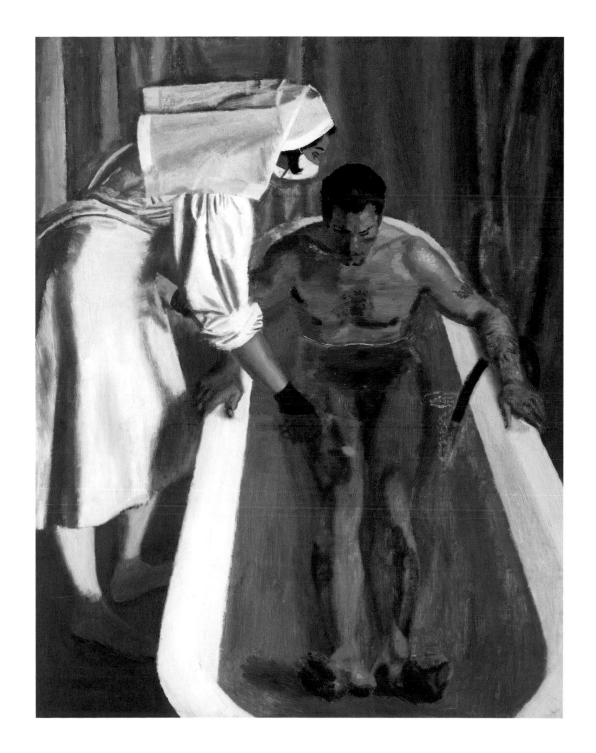

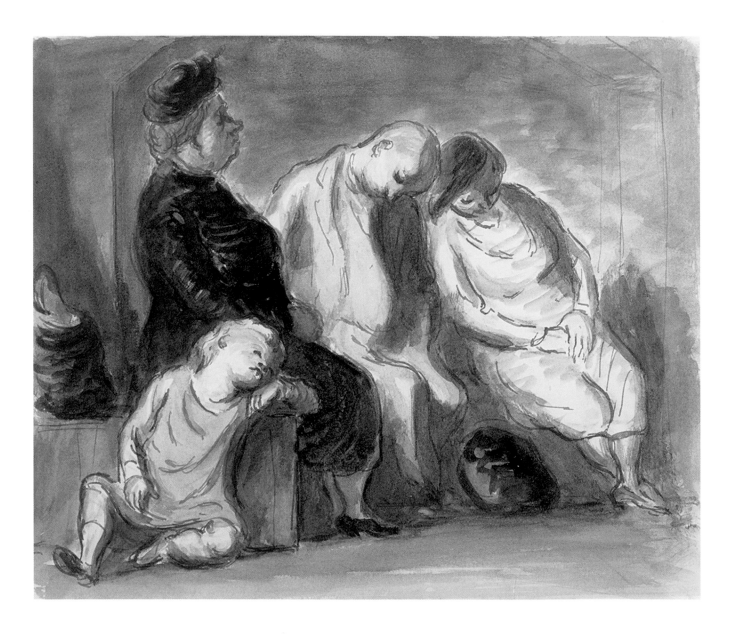

Edward Ardizzone CBE, RA

Shelter Group with Sleeping Child, 1940

watercolour on paper, 26.3 x 3.17 cm

This view of a shelter during the London Blitz is one of many images that were commissioned and purchased by the WAAC: the British government was anxious to show how civilians coped under fire and how adequate provision had been made for their defence.

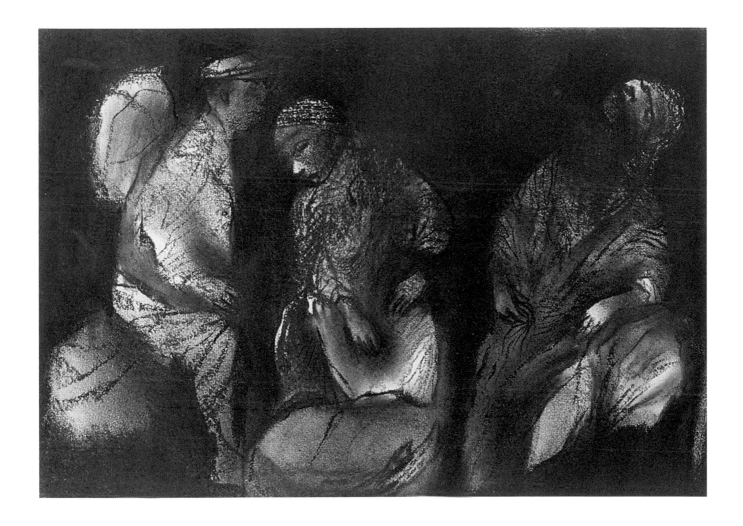

Mary Kessell

A Railway Station at Night, 1945

charcoal, 28.5 x 38.7 cm

Mary Kessell was sent to Germany in August 1945 to record the plight of the millions of refugees moving through Europe in the aftermath of the German surrender. She was one of only three female artists who were sent abroad. The following extract is from her diary.

Berlin, Tuesday 10 September 1945: The afternoon at the railway station Berlin. Shall I ever forget them? The scenes were quite the worst I've witnessed. Like Goya come to life. People sitting & lolling & sleeping – waiting for the trains that might come today or perhaps come tomorrow. Filthy, lousy, abject bundles of humanity. ... Remember for ever those things that war has made

William Scott CBE, RA

Soldier and Girl Sleeping, c.1943

oil on canvas, 40.9 x 50.8 cm
Supported by The Heritage Lottery Fund
Purchased with the assistance of The Art Fund

The soldier in a greatcoat and his girlfriend asleep on his shoulder on
a railway bench – a common enough sight in wartime Britain but
almost certainly autobiographical, as Scott's wife Mary remained in
Hallatrow, Somerset while he was stationed in London. Scott's
wartime paintings were a visualisation of his own inner feelings and
his experiences as a soldier.

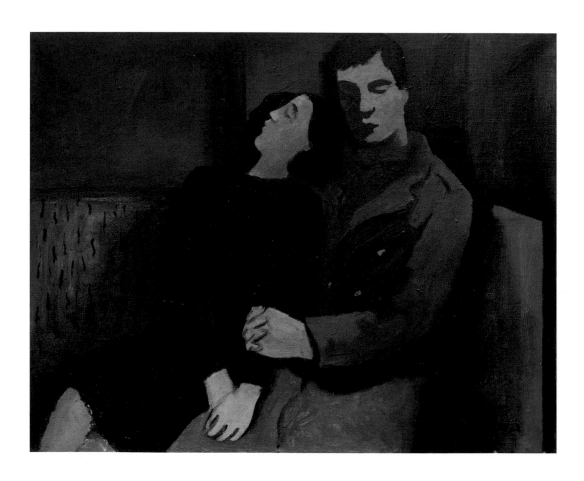

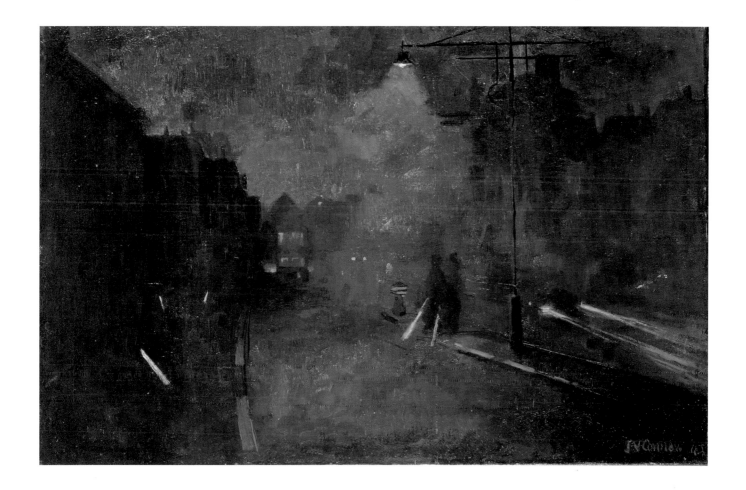

Joan Connew

Blackout, 1942

oil on canvas, 50.8 x 76.2 cm

The scene is in Bromley, Kent. Torchlights and headlights barely pierce the enshrouding pea-soup mist, making any progress seems fraught with difficulties. The painting was purchased by the WAAC after it had been seen at an Artist International Association exhibition.

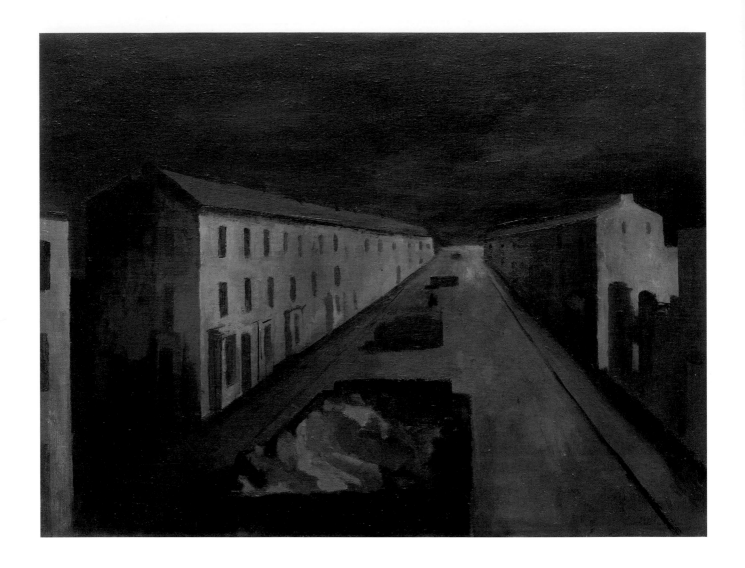

William Scott CBE, RA

Night Convoy, 1943

oil on canvas, 50.5 x 67.0 cm
purchased 1973

Scott was initially drafted into the Royal Engineers and based in London before being transferred to the Ordnance Section in Ruabon, Wales, where artists, designers and printers worked on map production. This eerily silent scene of khaki-coated soldiers being driven though a deserted and darkened one-street town is from this period. The sharply diminishing perspective conveys the sense of an interminable and meaningless journey. Scott himself recalled: 'We were always driving somewhere, we were never told where and it was always night'.[7]

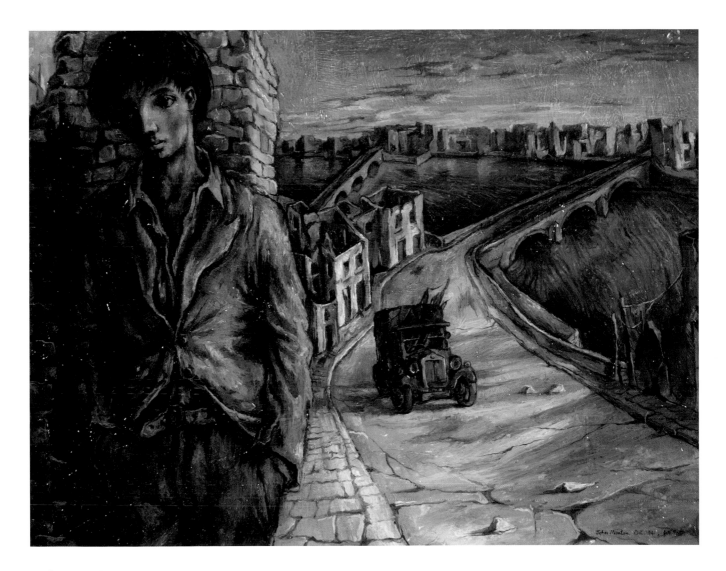

John Minton

Blitzed City with Self-Portrait, 1941

oil on board, 30.5 x 40.0 cm
Purchased with the assistance of The Art Fund, 2001

OVERLEAF:

Wapping, 1941

oil on board, 25.0 x 40.8 cm (detail)
Gift of Margaret Dale

These paintings are a revealing expression of Minton's state of mind when he knew his conscription was imminent (he had lost his claim to be a conscientious objector and joined the Pioneer Corps in December 1941). London had been transformed by preparations for war and then by the German bombing campaign which devastated those areas along the Thames that Minton liked to frequent – Wapping, Limehouse and Poplar. War had created a type of landscape that had previously existed only in his imagination. These paintings are an expression of his guilt, alienation and melancholy.

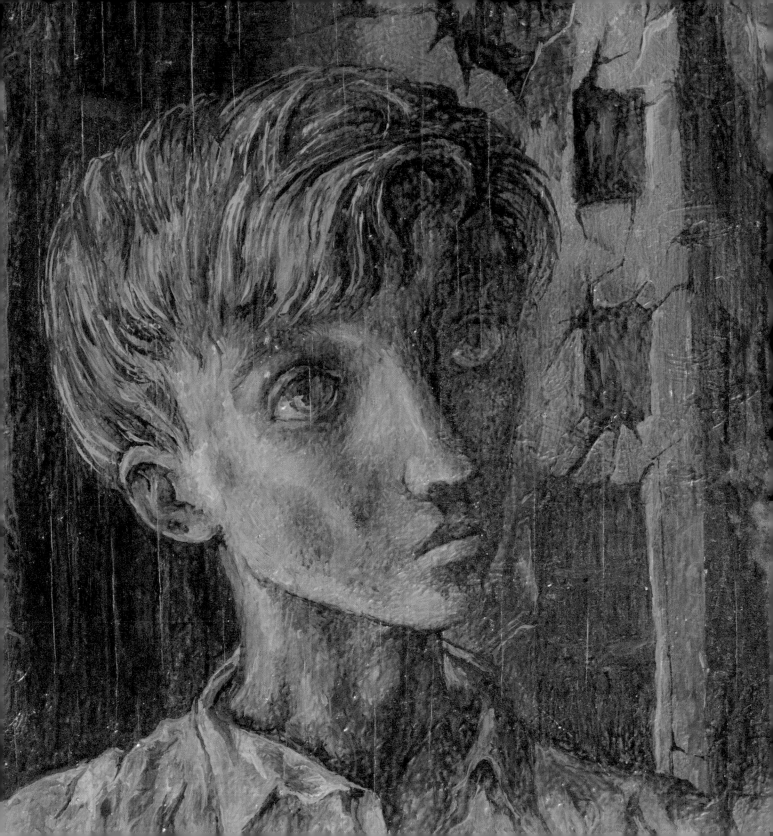

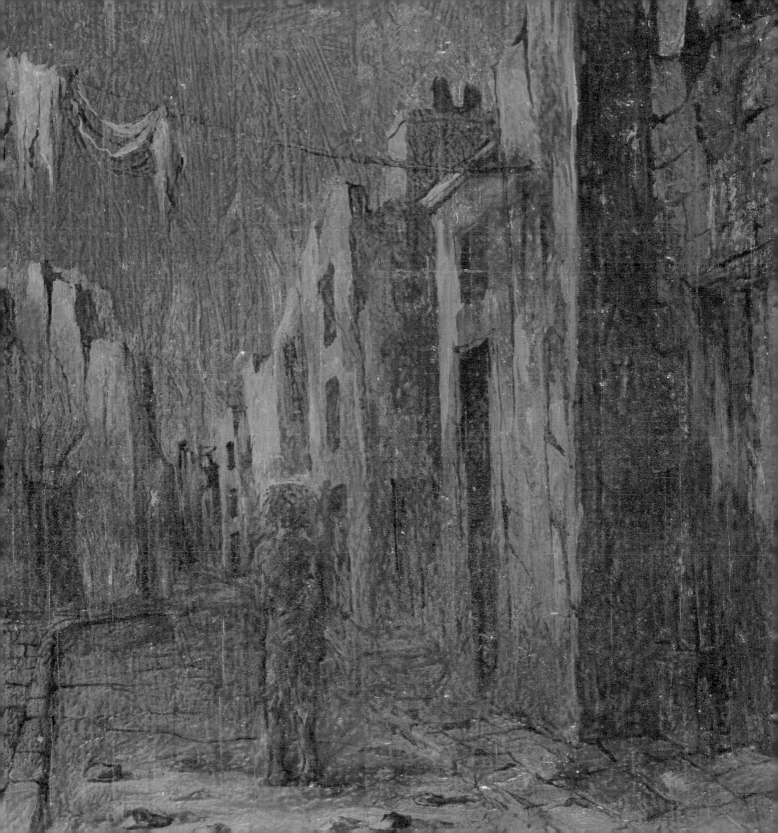

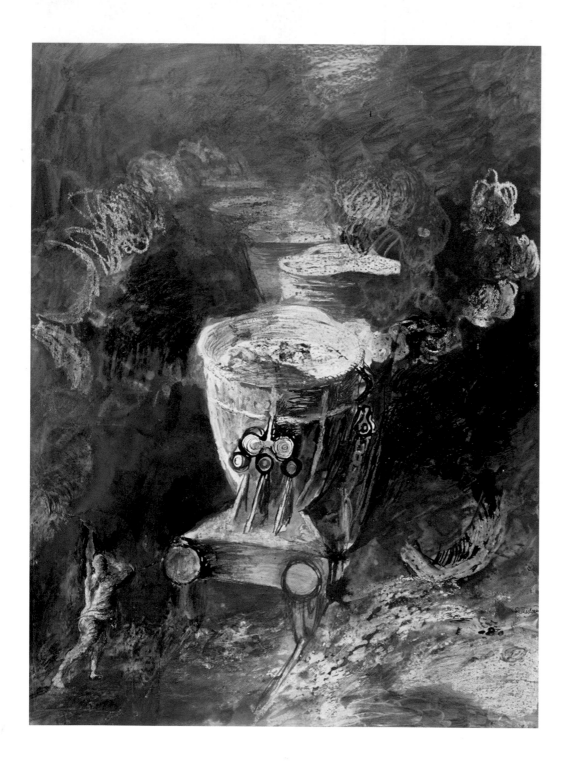

Graham Sutherland OM

Slag-ladles

gouache, 51.4 x 37.7 cm

Sutherland was first invited to discuss the possibility of a WAAC commission in June 1940 and what followed was almost continuous employment until the end of the war. Over the time of these commissions, Sutherland's subjects covered bomb damage in South Wales and London; iron and steel manufacture in South Wales; Cornish tin mines; opencast coal production; limestone quarrying in Derbyshire; and subjects in Northern France. Sutherland described the process of steel production as symbolising 'a kind of eternal war; a constant of conflict between the forces of man and nature, and intensified greatly during a war between nations, and in which man can only just emerge on top'.

Cecil Beaton wrote at the time: 'In this world of molten metals, of glowing furnaces, soot and fireworks sparks, that only the painter can interpret, Graham Sutherland has reverently seized his opportunity to capture this fleeting phenomenon of sequined brilliance, of mystery of glowing magic.'[8]

Henry Moore CH, OM

A Miner at Work, 1942

ink, chalk, gouache on paper, 49.5 x 49.5 cm

At his own suggestion, Moore was commissioned in August 1941 by the WAAC to make drawings of coal mining at Wheldale Colliery, Yorkshire, where his father had worked at the beginning of the century. The commission continued the underground themes of his shelter drawings but the human reaction to their environment is very different. Whereas the shelterers sought sleep and waited passively for the all-clear, the miners, although seemingly impossibly constrained, fight against the coal face.

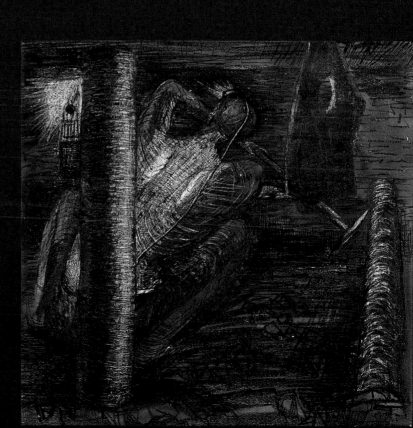

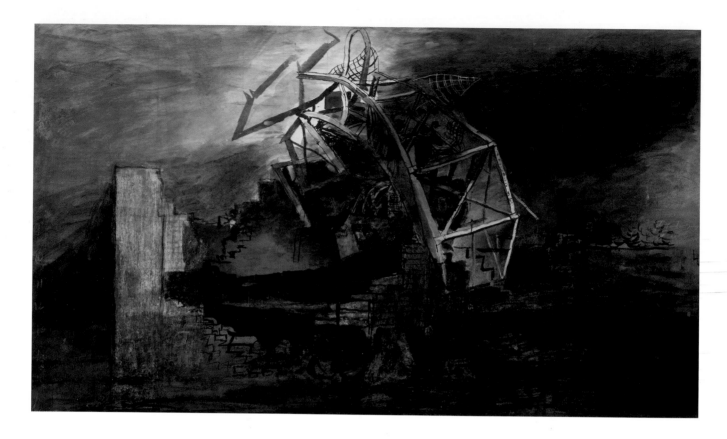

Graham Sutherland OM

The City: A Fallen Lift Shaft, 1941

gouache on paper, 67.5 x 113.0 cm

These bomb damaged buildings were in an area just north of
St Paul's Cathedral. Described by Sutherland as an eerie, foul-
smelling, deserted wasteland, it was one which he explored with
growing confidence during the Blitz, although occasionally
buildings would spontaneously collapse around him. Amid this
barren scene, Sutherland has animated the twisted structure,
creating a presence that both threatens and yet also implies the
possibility of new life.

Leonard Rosoman RA

**A House Collapsing on Two Firemen,
Shoe Lane, London, EC4, 1940**

oil on canvas, 91.8 x 76.8 cm

This horrific scene in Shoe Lane in the City of London was one that
Rosoman witnessed as a fellow fireman. The falling wall trails
chaos and disorder in its wake, its own rigid structure about to
break and kill the firemen still clutching their hoses. Rosoman later
expressed dissatisfaction with the painting as an over literal
response but the effect on the viewer is still powerful and intensely
disconcerting. The painting was exhibited in the Firemen Artists
exhibition at the Royal Academy in 1941.

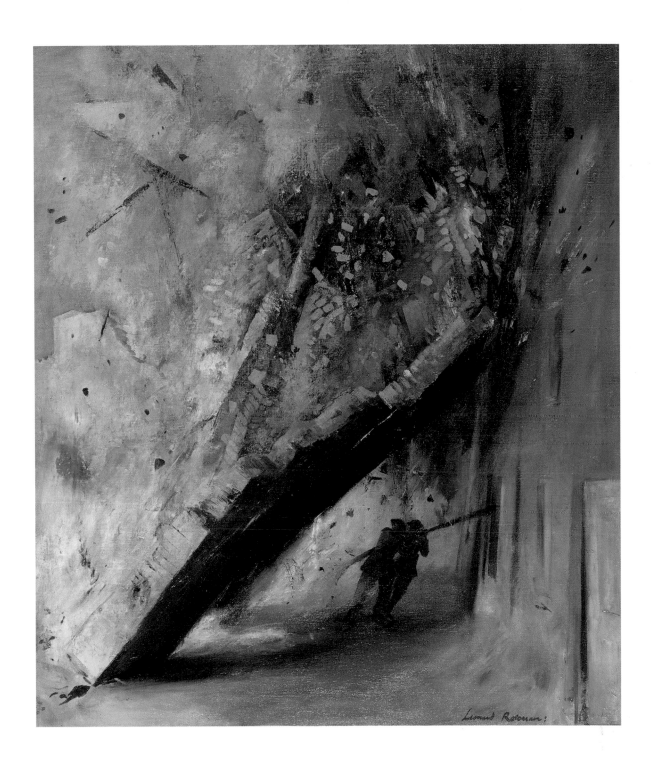

Paul Nash

Battle of Germany, 1944

oil on canvas, 121.9 x 182.8 cm

Nash wrote a text to accompany the painting: '... The moment of the picture is when the city, lying under the uncertain light of the moon, awaits the blow at its heart. In the background, a gigantic column of smoke arises from the recent destruction of an outlying factory which is still fiercely burning. These two objects – pillar and moon – seem to threaten the city no less than the flights of bombers even now towering in the red sky. The moon's illumination reveals the form of the city but with the smoke pillar's increasing height and width, throws also its largening shadow nearer and nearer. In contrast to the suspense of the waiting city under the quiet though baleful moon, the other half of the picture shows the opening of the bombardment. The entire area of sky and background and part of the middle distance are violently agitated. Here forms are used quite arbitrarily and colours by a kind of chromatic percussion with one purpose, to suggest explosion and detonation. In the central foreground the group of floating discs descending may be a part of a flight of paratroops or the crews of aircraft forced to bale out.'[9]

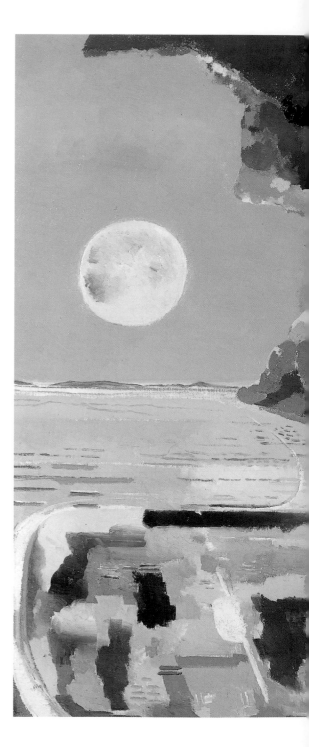

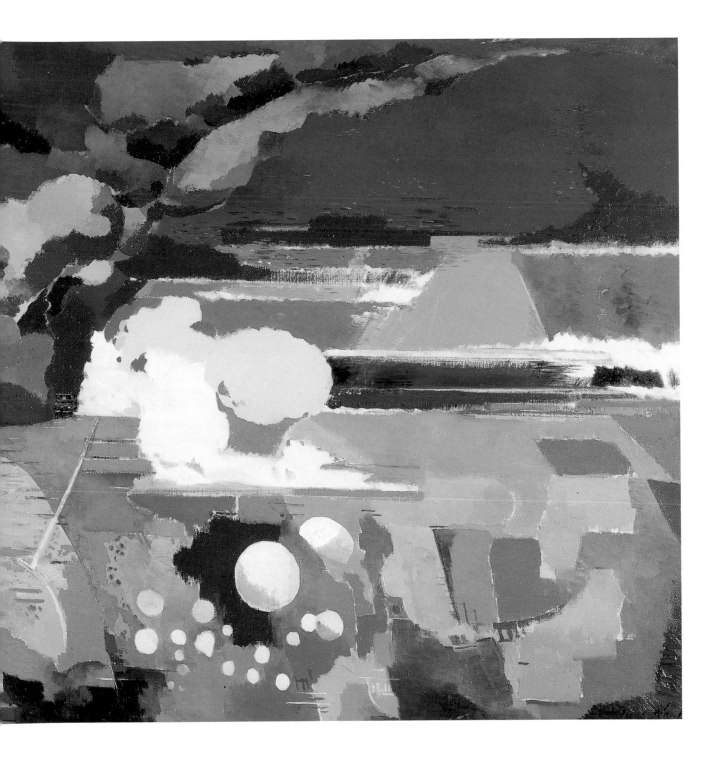

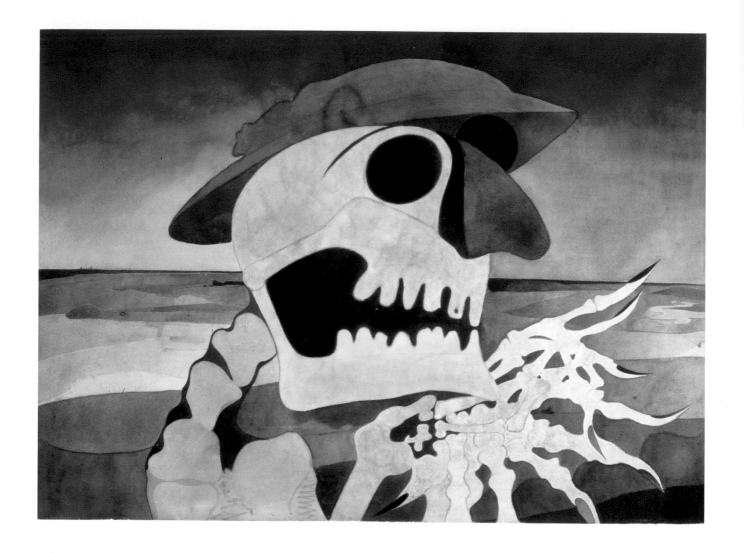

Edward Burra

Skull in a Landscape, c.1946

watercolour, black chalk on paper, 57.0 x 78.0 cm
purchased, 1982

Burra was appalled by the cruelty of war and saw it as a descent into barbarism. Here the grinning skull mocks mankind, who has brought about his own destruction. The flat brown landscape recalls the Western Front, and the blood red sky could be taken as a symbol of the death of millions in the Second World War, and more particularly the extinction of the Japanese cities of Hiroshima and Nagasaki by atomic bombs in 1945.

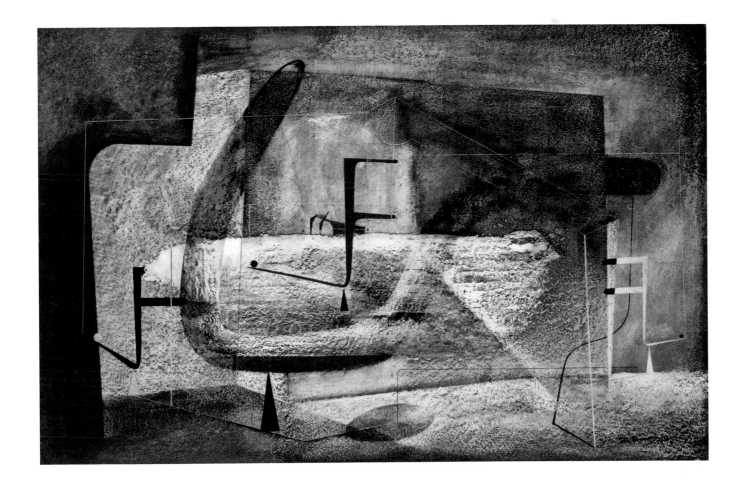

John Tunnard

Anglo Dutch, 1942

tempera oil on board, 65.0 x 95.0 cm
Purchased with the assistance of The Art Fund, March 2000

Tunnard served as a coastguard in Cornwall during the war. Interspersing long periods of sea gazing with his own paintings. *Anglo Dutch* was an ocean-going cargo ship. In the painting it seems to float inside the massive yet transparent shape of a naval fort or sea wall – the sea at its foot meets the dark grey sky on the right. The oxide red suggests the rusting sides of ships. The shapes of rudders, a ship's prow, weather dogs, signal masts and the triangles and dots of chart symbols pierce and enlace the bold forms in the centre.

The combination of technological forms and symbols were intended to give a vision of a future reality, and his paintings capture the essential modernity of the Second World War.

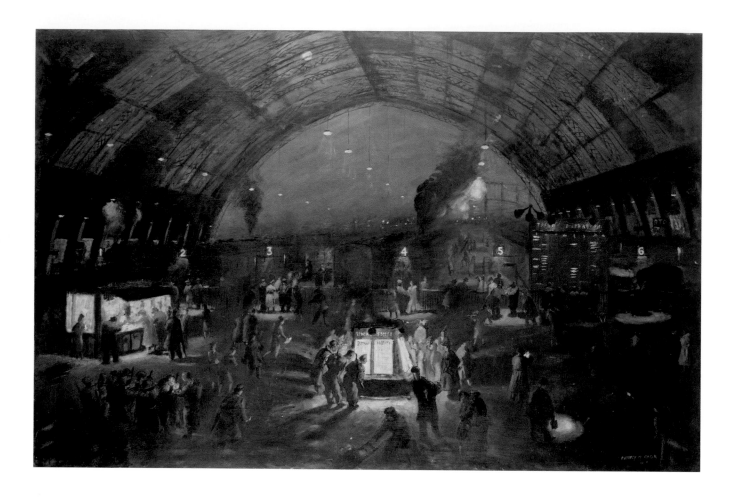

Henry Carr RA

A Railway Terminus, 1941

oil on canvas, 99.0 x 149.8 cm

The great arched roof of St Pancras Station (the exact location would have been removed from the title for security reasons) shelters an active and lively community that gathers around the lights like moths. The station offers the last comfort, nourishment and information before the trains leave towards the darkness of North London.

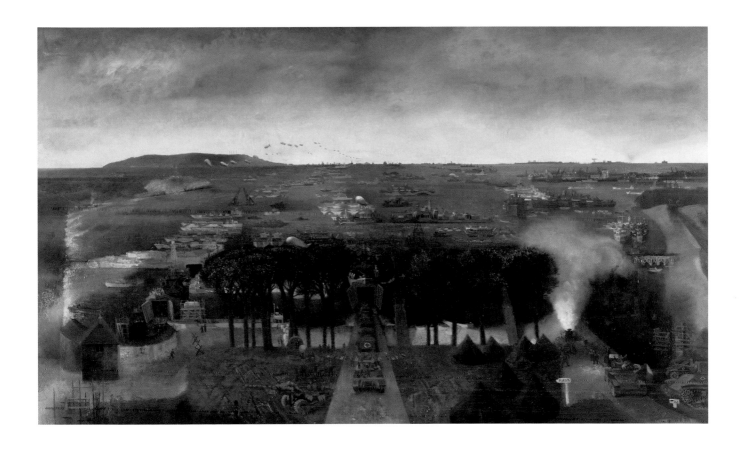

Richard Eurich RA

Preparations for D-Day, 1944

oil on canvas, 76.2 x 127.0 cm

Eurich's enigmatic composite painting of land and naval forces massing off the South Coast before D-Day gives an impression of brooding calm before the storm. The dark belt of trees across the centre of the painting obscures the transition from land to sea. The roads end in barriers of smoke or barbed wire and the only way forward is into the unknown, through the huge jaw-like hold-doors of the central ship. Camouflage netting, smoke screening and the camouflaged shipping all contribute to the sense of secrecy and hidden strength conveyed by the painting.

His wartime style has been compared to the sixteenth century Flemish painter Pieter Breughel whose work shows a similar attention to distant detail and purposeful activities. Indeed, the gaping ship's doors seem to echo Breughel's *Mouth of Hell*, making a visual equation between war and hell which agrees with Eurich's Quaker background and beliefs.

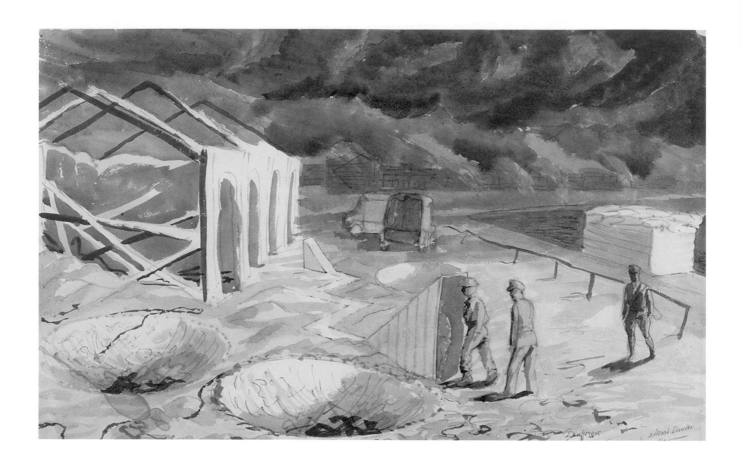

Edward Bawden RA

The Quay at Dunkirk, 1940

watercolour on paper, 30.4 x 49.2 cm

Bawden was an official war artist for the whole period of the war. He was initally sent to France, and then evacuated from Dunkirk with the British Expeditionary Force the following year. He was then sent out to the area under Middle East Command, arriving in Cairo, and travelling down through East Africa. In early 1942, he travelled into North Palestine and Lebanon with Anthony Gross, and spent several months in Iraq. On his way back to England later in the year, the ship was torpedoed, and Bawden spent two months in a camp outside Casablanca before he was liberated by the Americans. He returned to Iraq in 1943, travelling to Kurdistan, Iran, Saudi Arabia, and spent a period in Italy, before being recalled to England in 1945.

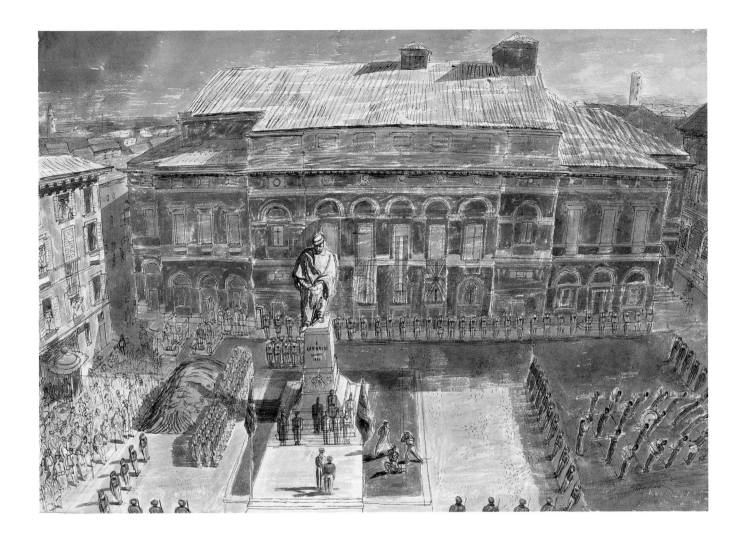

Edward Bawden RA

Ravenna: Lieutenant-General Sir Richard McCreery decorates Bulow, the partisan leader, with the Medaglio d'Oro for conspicuous personal bravery, 1945

watercolour on paper, 56.8 x 78.6 cm

Arrigo Boldini (codenamed Bulow) was the leader of the XXVIIIth Garibaldi Brigade 'M. Gordini'; the partisan force which liberated Ravenna, on 4 December 1944, with the approval of the Allied Forces. General McCreery was the Commanding Officer of the 8th British Army in Italy. Bawden perched on the roof of the municipal building in Ravenna to record this presentation in the Piazza Garibaldi. He described the scene to his wife: 'Most of the square was clasped in shadow, only a few houses at one end and Garibaldi raised high on a pedestal caught the light, and his figure in white stone dominated the scene …'.[10]

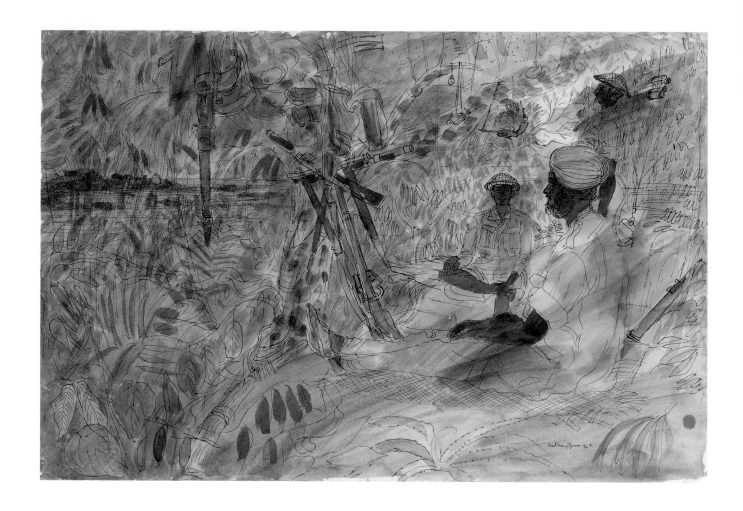

Anthony Gross CBE, RA

**Battle of Arakan, 1943: A Command Post
overlooking South Twin Hill, 1943**

ink, wash, 36.8 x 55.2 cm

Gross was sent to Burma to illustrate British and Indian commitment to the area.
Here he captures the complex patterns and light of the jungle, and the ability of
the troops to survive and acclimatise to their unusual conditions. Hanging
from the camouflage netting are their kit and weapons whilst they wait on the
Japanese in still silence. Gross was an official artist who travelled extensively
during the war. He crossed the Channel on D-Day and followed Allied forces
on into Germany.

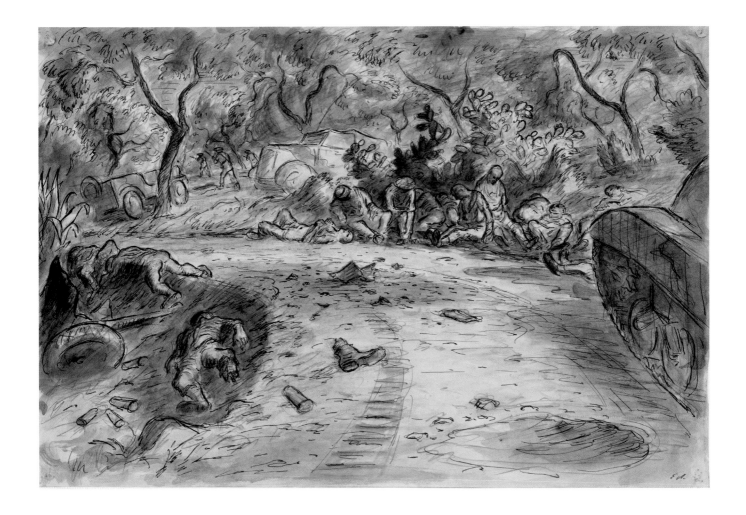

Edward Ardizzone CBE, RA

Battle in an Orchard of Almond Trees in Sicily: Morning of July 21st, 1943

watercolour on paper, 38.0 x 55.0 cm

On 21 July 1943, Brigadier-General Rennie's 154th Brigade attacked Gerbini airfield, spearheaded by 7th Argyll and Sutherland Highlanders. The defences they encountered included deep wire, machine guns and tanks. After three hours the objective was taken, but casualties were heavy. Meanwhile, on 1st Canadian Division's front throughout the day, the men of Tweedsmuir's force at Assoro beat off German counter-attacks. Ardizzone was present and recorded the events in his diary: 'Go forward and get involved in not too pleasant a battle. The approach to the ridge,'ware mines. Tanks on the road, many dead, wounded under cactus hedge, the burning corpse. Tanks burning and blowing up in an almond orchard.'[11]

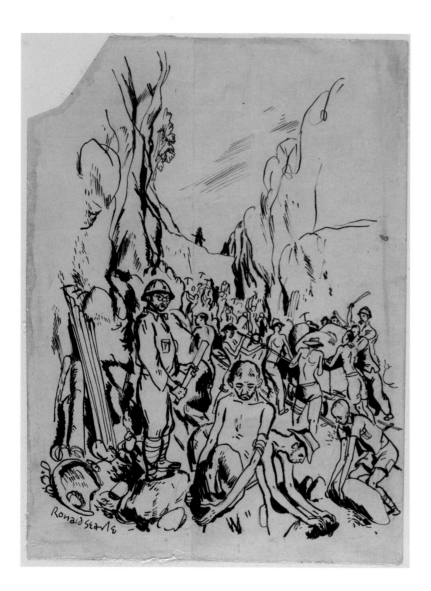

Ronald Searle

In the Jungle – Prisoners Cutting into the Mountain near Konyu, Thai-Burma Railway, June 1943

ink pencil on paper, 21.5 x 15.3 cm
Gift of the artist, 1984

Searle's art studies were interrupted by the war when he joined the Territorial Army as an architectural draughtsman in 1939. In 1941 his brigade left for the Far East, travelling via Cape Town. They arrived in Singapore, and were taken prisoner of war by the Japanese after the invasion in 1942. Searle was part of the mass of allied prisoners who worked on the Thai-Burma railway construction, and was then transferred to Changi Gaol, in Singapore in May 1944. In August 1945 the Japanese guards withdrew from the prison and Searle returned to England not long after. He took with him the drawings he had made during his three years of captivity, which he presented to the Imperial War Museum in 1984. This section of the railway, better known as Hellfire pass, was infamous for the brutality of the guards and the loss of life amongst the prisoners.

Leslie Cole

British Women and Children Interned in a Japanese Prison Camp, Syme Road, Singapore, 1945

oil on canvas, 65.5 x 91.5 cm

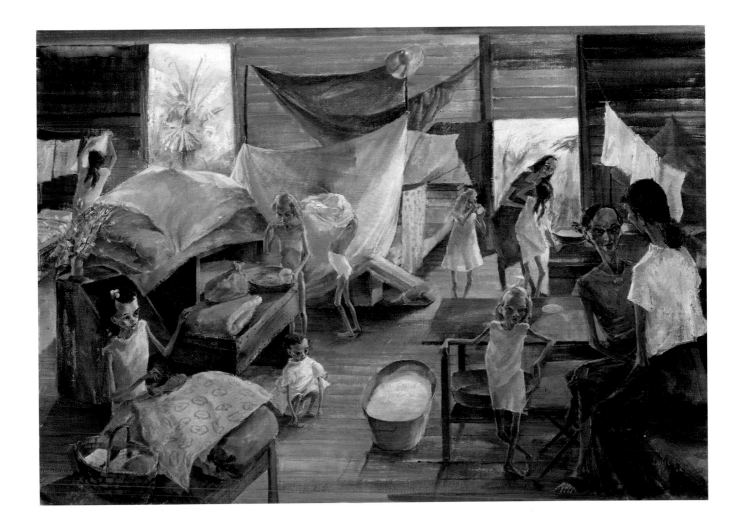

As the war progressed, and with it Cole's experience of extraordinary and often horrific events, his work became increasingly macabre, with a symbolic use of colour evident in the unsettling yellow-green cast of the painting.

In the image of internment there is an anguish in the skeletal figures appearing to carry out daily domestic activity. The unimaginable had become every-day. The angular malnourished children with stick-like limbs and hollow eyes become almost translucent and insubstantial. The painting has an underlying theme of cleansing – the bath of water, the swathes of white sheets and draped washing and the clarity of the pale sunshine illuminating the room – all suggest a quiet redemption from the dark days of imprisonment.

Morris Kestelman

Lama Sabachthani, 1943 [*Why have you forsaken me?*]

oil on canvas, 117.0 x 153.0 cm. Gift of Sara Kestelman, 1999

This was painted at a time when news of the Nazi concentration and death camps was starting to filter through to British society. Although geographically distant, the impact was keenly felt in some quarters. The quotation is taken from Psalm 22. The tension for the psalmist is in the possibility that God might not rescue, and applied to this context where intervention seemed neither feasible nor imminent, it questions the very rule and presence of God. The awfulness of such a possibility and its unthinkable consequences, as well as the horror of their immediate circumstances, is writ large in these figures. Their pleading is set against a backdrop of burnt cities: dense smoke and clouds almost smother the canvas and their cries.

Doris Zinkeisen

Belsen: April 1945

oil on canvas, 62.2 x 69.8 cm

During the war Zinkeisen worked as a nurse in London before she became an artist for the Red Cross in Europe. Based in Brussels, she was able to visit Belsen within days of it being liberated.

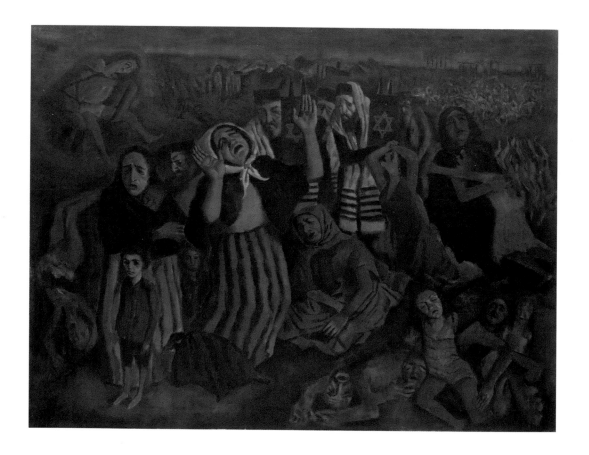

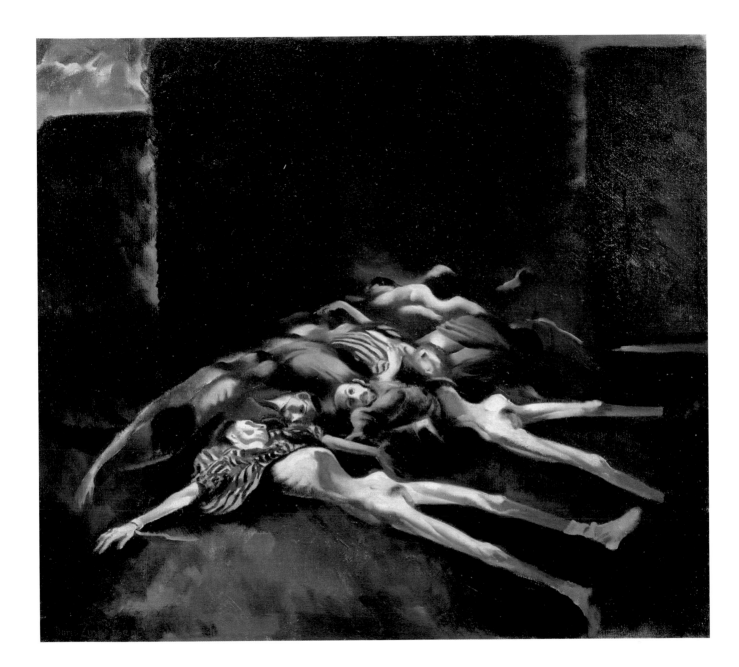

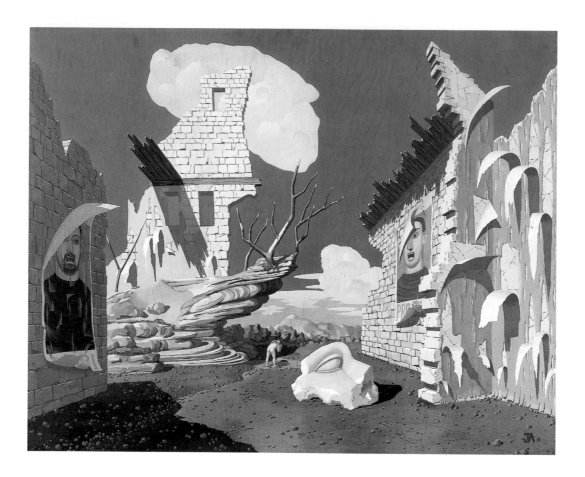

John Armstrong ARA

Pro Patria, 1938

tempera on board, 75.8 x 93.6 cm
Purchased with the assistance of the National Heritage
Memorial Fund and The Art Fund, 1995

Armstrong shared the deep concern of artists and intellectuals over the events of the Spanish Civil War and his work took on political overtones in the late Thirties which intensified during the Second World War. In 1938, he visited Rome and saw Mussolini's political slogan 'Pro Patria' on posters all over the city. His artistic response is this scene of muted horror. Something terrible has occurred – a massacre or a violent death amid ruins that had once been a refuge. Human responses are captured in the expressions of anguish in the stylised Byzantine heads on the posters. The fragment of classical statuary and the gigantic strips of peeling wallpaper are metaphors for the destruction of European civilisation and human values. Armstrong's first commissions as a war artists would be of damaged buildings.

Robert Blyth RSA

In the Image of Man, 1947

oil on canvas, 127.0 x 101.6 cm

Painted shortly after the end of the Second World
War, this is a damning image of its outcomes.
The title parodies the Judeo-Christian teaching of
man made in the image God and presents a world
left to man's own devices. Western Civilisation is in
ruins: its symbols of comfort and power are
destroyed and scattered, and its spiritual vision is
broken and empty.

Blyth joined the Royal Army Medical Corps in
1941. Towards the end of the war, 157 Ambulance,
his own unit, was based in Hamburg and this is
probably the setting of the painting. The city had
been devasted by RAF firebomb raids over four
nights in July 1943.

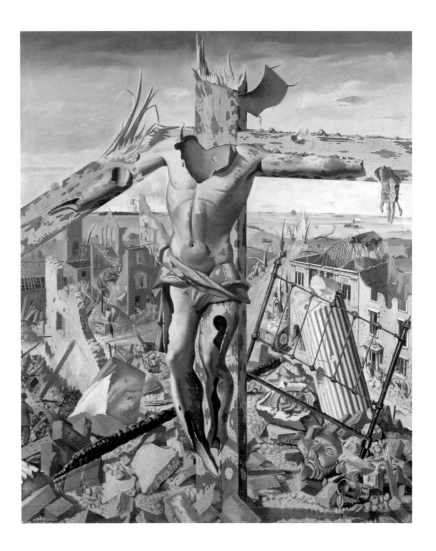

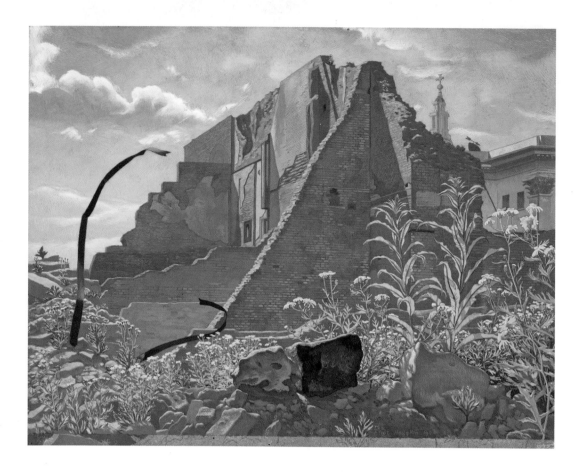

Eliot Hodgkin

The Haberdashers' Hall, 8th May 1945

tempera on panel, 29.2 x 36.8 cm

Hodgkin was renowned for his beautifully observed paintings. Whilst working for the Home Intelligence Division of the Ministry of Information, he wrote to the WAAC proposing a commission, 'which will make some use of my special abilities – such as they are – and be a bit less uncongenial than the civil services. ... It has occurred to me that possibly no pictorial record has so far been made of colonisation of London's bombed sites by willow herb, ragwort etc.'[12]

Leila Faithfull

VE Day Celebrations outside Buckingham Palace, 8 May 1945

oil on canvas, 34.2 x 111.7 cm (detail)

For the first time in years, crowds can gather in open daylight on the streets of London, free from fear of aerial attack. Through the shadows, we see the rainbow colours of the crowd straining to see the celebrations at the Palace.

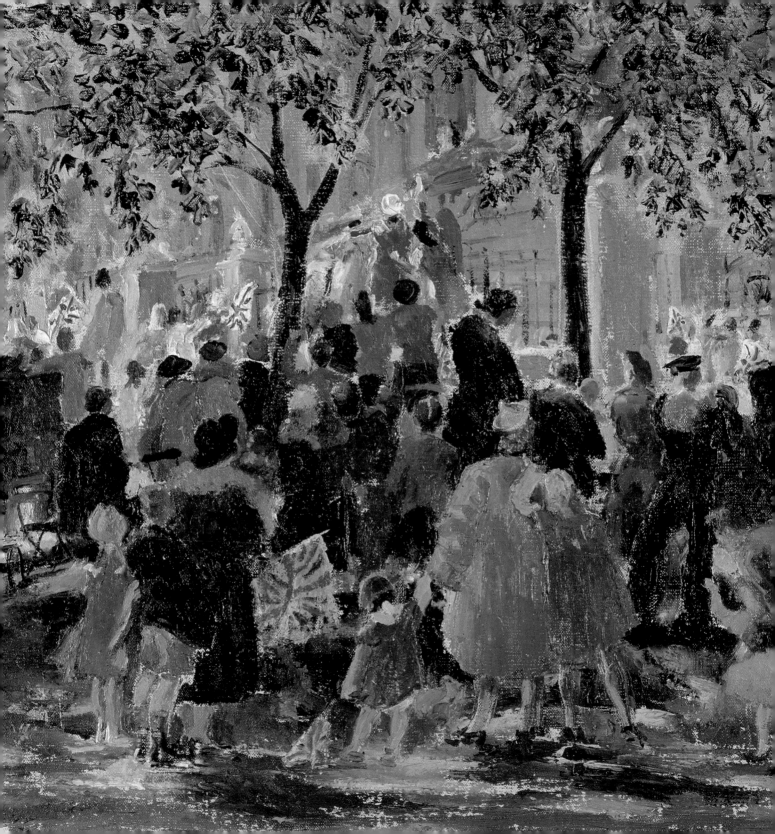

Sir Jacob Epstein

The Rt Hon Winston Churchill, 1947

bronze, 31.0 x 19.0 x 24.5 cm

Aware both of Epstein's reputation as a modernist and the recent controversy of Graham Sutherland's portrait, Sir Kenneth Clark explained the committees choice to Churchill 'he is almost the only distinguished living master of the portrait, and we find that the busts he has done for us already show a much greater measure of truth than any other portraits we have commissioned.'[1] The bust of Churchill was commissioned in August 1945, shortly after Churchill's election defeat in July but Churchill was not available for sitting until the winter of 1946–47. This is a powerful work. Churchill's ringed eyes display not only focus but also clarity of vision: the rough surface, his formidable grit and determination.

RIGHT:

Renato Giuseppe Bertelli

Profilo Continuo (Testa di Mussolini), 1933 [Continuous Profile (Head of Mussolini)]

terracotta with black glaze, 34.0 x 28.0 x 28.0 cm

In line with Mussolini's re-creation of Roman traditions, Bertelli draws from images of the Roman god, Janus. However, whereas Janus had two faces to look into the past and the future, Mussolini is able to look in all directions. Bertelli had also become interested in Futurist ideas and the theories of F T Marinetti during the 1920s and the head embodies their passion for machines, speed and power. The image is very much in keeping with Mussolini's own self-publicity of the time which presented him in the role of technological and cultural pioneer.

BACK COVER:

John Armstrong ARA

Can Spring Be Far Behind? 1940

gouache on paper, 53.9 x 38.1 cm

The oversized flower emerging from the destruction of the Blitz is Armstrong's ironic view of Britain's darkest hour.

NOTES

1. Imperial War Museum War Artists Archive (IWMWAA)
2. IWMWAA
3. Gowers' obituary
4. IWMWAA
5. IWMWAA
6. IWMWAA
7. Quoted by A Weight in William Scott: War Paintings 1942–46, Imperial War Musuem, 1981
8. C Beaton, 'Introduction', Production, 'War Pictures by British Artists' (Second series, No 2), London, 1943
9. IWMWAA
10. Imperial War Museum Department of Documents
11. E Ardizzone, War Diaries, Volume 1
12. IWMWAA

Published by the Imperial War Museum
Lambeth Road, London SE1 6HZ

© The Trustees of the Imperial War Museum, 2007

Designed by James Campus
Printed by Graphicom SPA, Italy